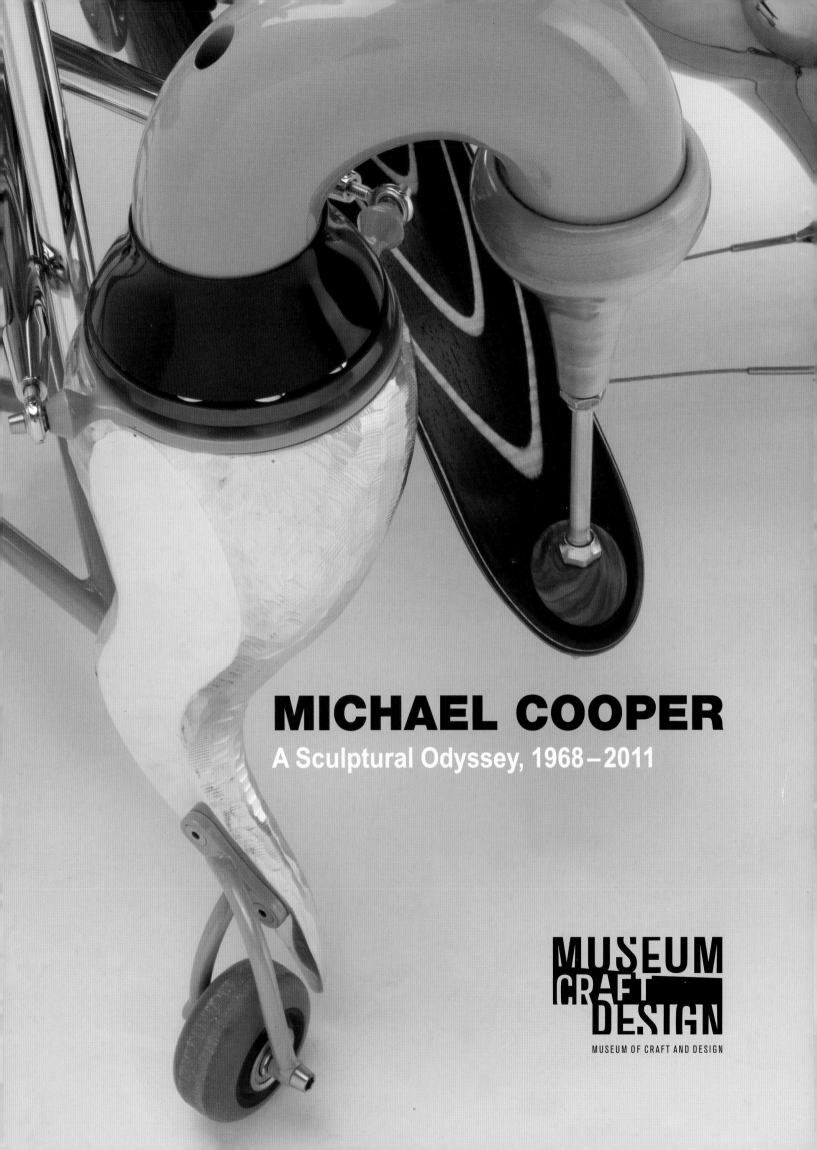

MICHAEL COOPER
A Sculptural Odyssey, 1968–2011

MUSEUM CRAFT DESIGN

MUSEUM OF CRAFT AND DESIGN

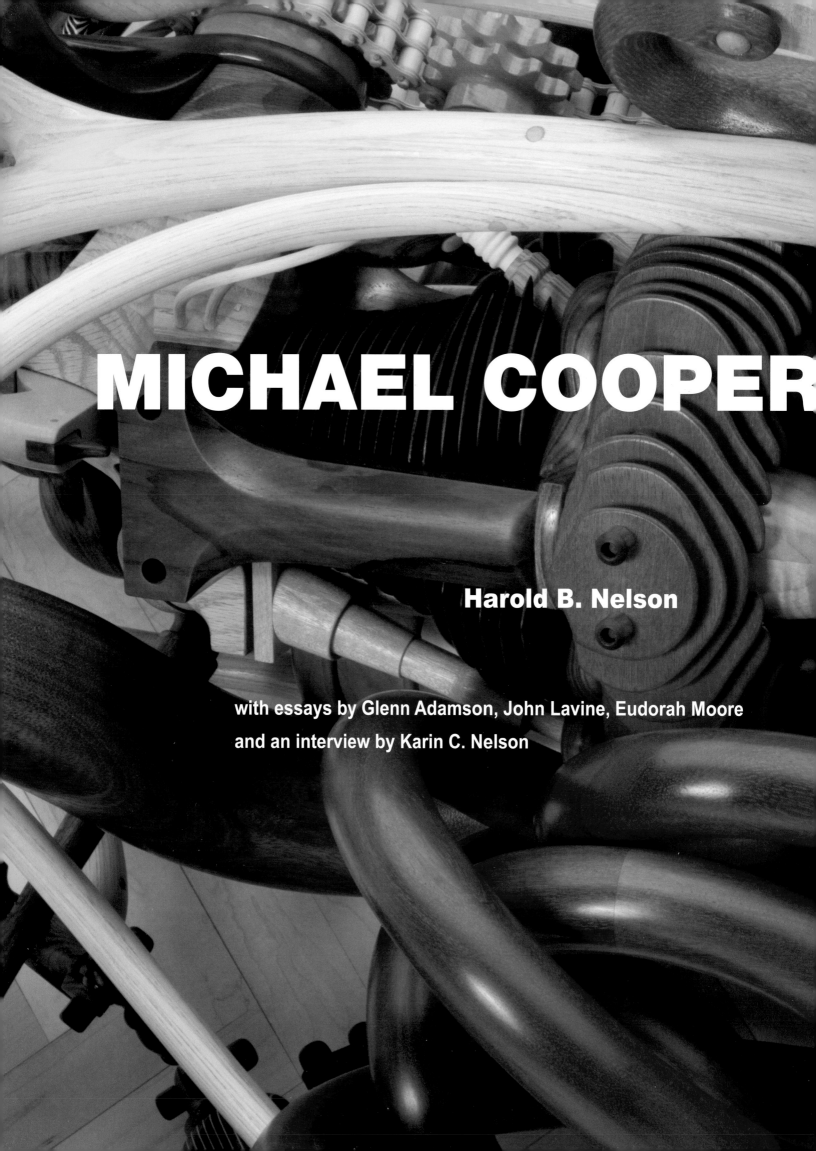

MICHAEL COOPER

Harold B. Nelson

**with essays by Glenn Adamson, John Lavine, Eudorah Moore
and an interview by Karin C. Nelson**

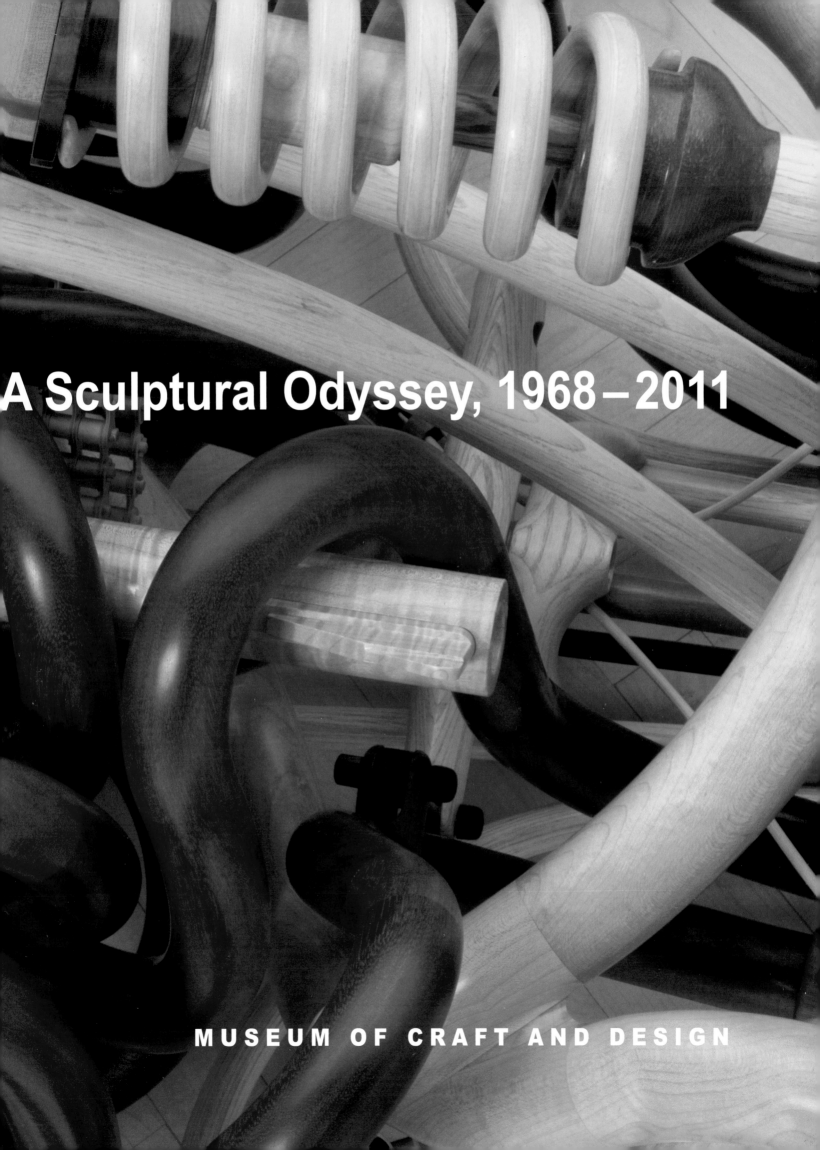

A Sculptural Odyssey, 1968–2011

MUSEUM OF CRAFT AND DESIGN

Foreword

It's hard to discern which is more important, Michael Cooper's beyond-belief sculpture, or the influence of his teaching and unfaltering guidance on thousands of students, many of whom have become successful artists in their own right. Notwithstanding his unflagging obsession to conceive and realize extraordinary work, Cooper has a legacy in the students he has mentored over his thirty-five-year teaching career. Both are equally compelling; for the first time, however, this publication proudly venerates his life's work in sculpture.

Michael Cooper is an incomparable artist who relentlessly challenges and expands any preconceived boundaries between art, craft, and design with his feet firmly planted in all worlds. Cooper's outrageous contraptions command and merit our high regard, inciting curiosity and pure wonder in those who experience them. Suspended between technological invention and creative genius, his work is accessible to all, yet like none seen before. Recognized for its flawless precision and craftsmanship, his sculpture continues to be admired by those who appreciate his brilliance of design and the junction between art and science. Cooper is completely driven in his practice and expends huge amounts of time conjuring ideas and bringing them to fruition.

Michael Cooper and his wife, Gayle, welcome those interested in his work to his studio and their home with big-hearted warmth, always eager to answer questions and to share one of Gayle's infamous gourmet meals. At sixty-seven, Cooper remains humble, shy, and thoughtful, following a clear path to creating all that he imagines, supported all the while by Gayle. Both have been generous in their efforts to help with this exhibition, and for that we are most appreciative.

We are pleased to be presenting *Michael Cooper: A Sculptural Odyssey, 1968–2011* as our first traveling exhibition and are extremely grateful to our contributors. Enormous thanks goes to the Windgate Charitable Foundation for their lead support with this project and for their visionary philanthropic work in the arts. Friends whose contributions have helped make this exhibition possible are: Grants for the Arts/San Francisco Hotel Tax Fund, Bobbi and Fletcher Benton, Ross Periodicals, Inc., Cycle City Ltd., Marc Adams: Marc Adams School of Woodworking, and John and Diane Pashilk.

Additional thanks go to the lenders for their willingness to allow these important works to travel to participating venues: Michael and Gayle Cooper, Kia and David Hatch, John and Kathleen Holmes, Dick and Cindy Long, John and Diane Pashilk, Lucia Ryerson, Salvador Dali Museum, Sam and Alfreda Maloof Foundation for Arts and Crafts, Jacqueline Thurston, Dennis and Kathy Varni, Richard Wickstrom, and Walter Wilson. Because of their generosity, others throughout the country will have the opportunity to see this remarkable body of work.

Our guest curator, Hal Nelson, and our writers Glenn Adamson, John Lavine, Eudorah Moore, and Karin Nelson are second to none, and we are indebted to them for their significant contributions to this exhibition and publication. I also want to acknowledge Michael Chase for his exquisite photography of Michael Cooper's work and Ron Shore for his stellar catalogue design.

The Museum of Craft and Design would not continue to flourish without the dedication and indefatigable hard work of its key staff: Allison Simpson, Mariah Nielson, and Raymond McKenzie. Our part-time staff and volunteers also contribute an invaluable component to the successful workings of MCD. Others who deserve our gratitude are those who have provided us with generous pro bono services: Michael Osborne Design, Gauger + Associates, McCall Design Group, Ted Cohen, Steve Oliver, and Gary Hutton Design.

Last, but certainly not least, our Board of Directors and National Advisory Board merit tremendous thanks for their vision and support. Ultimately, the Museum of Craft and Design would not exist were it not for them.

JoAnn Edwards, Executive Director

Introduction

MICHAEL COOPER

A Sculptural Odyssey, 1968–2011

Michael Jean Cooper is best known for his complex and adroitly crafted mixed-media sculpture, works that depict seemingly commonplace objects transformed by the artist's wit, his keen insight into human nature, and his extraordinary technical facility. His fantastical "vehicles," including pistol-packing tricycles, astoundingly intricate wooden hot rods that don't quite go anywhere, and curiously mobile forms of "furniture," underscore his role as one of the most imaginative sculptors working today. While some of the artist's amusingly dysfunctional forms serve as a counterpoint to the traditional association of craft and utility, others—including a whole series depicting weapons—critique contemporary society and its fascination with sex, power, and violence. During the forty-year period explored in this "sculptural odyssey," Cooper's work has become increasingly complicated and multi-layered, culminating in his monumental, kinetic, computer-driven work entitled *How the West was Won, How the West was Lost*, a sculptural treatise on conquest, greed, and lust for power, concepts as topical today as they were when the artist first began the work in 1977.

Early Years

Born in Richmond, California in 1943, Michael Cooper was raised in Lodi, a rural community in California's Central Valley, where he enjoyed a classic "all-American-boy" childhood. In describing his idyllic youth in this small-town setting, Cooper recalls that popular culture and cars played an important role in his development. "I grew up in the '60s listening to the Beatles and surfing records. It was easy to get a car and you had one as a matter of course by the age of sixteen. Mine was an old Model A Ford in bad shape. The sun was shining for us though and it was easy to fix up cars." On the pervasiveness of the 1960s California car culture and its impact on his development, he observed: "Cars were an extension of our personalities…I disassembled my Model A and it was such an awesome task to put it back together it is still apart. After that I had real hot rods, modified engines, no fenders. I worked at them in the carport and we all borrowed each others' tools and welding equipment. In the crudest possible way we were learning about design by the seat of our pants." (*Craft Australia*, p. 21) For Cooper, tinkering with engines was a central part of his teenage years. It was also a shared pastime, a bonding experience among his boyhood friends and cronies. It was during this period that he developed his lifelong love of engines and automated vehicles—subjects that frequently appear in his later work.

During this period Cooper was also studying carpentry and woodwork-ing techniques with his uncle and his grandfather, who had a cabinetmaking business. On his attraction to this medium, Cooper has said: "Wood is both interesting and extremely workable. People have a strong bond with wood. They are comfortable with

it. They look at it differently. What is normally a quick glance at a metal object becomes a lingering look at wood and there is time to relate to the idea because the material holds the interest." (*Craft Australia*, p. 22) Cooper pursued his passion over the next forty years, exploring wood's inherent beauty as he exploited its richly varied formal, technical, and expressive potential.

The artist's fascination with weapons, particularly pistols, also developed during his youth. His desire to have a gun led to a keen understanding of its power and an acute realization of his own destructive potential. As he stated: "As a small boy, like all my friends, I longed for the day when I could have a gun and go hunting. One day I borrowed a BB gun and I shot a small bird. I was really horrified by the result. It bothered me that I had killed something. Before that, my excitement was all about shooting and hunting but when it was done it really sank home that I had killed the bird." (*Craft Australia*, p. 22) Guns were to take on an even more terrifying aspect when his life was threatened during a robbery attempt at his grandfather's store. The artist reflected: "When I was a teenager, I was minding my grandfather's little corner store which my father managed when I was held up. The experience was terrifying. The man was huge. He was six feet nine inches tall and weighed 270 pounds. He was desperately nervous, the gun shaking and pointing in his hand as he ordered me to lie down on the floor. I thought he was so nervous that he would kill me accidentally as I lay there hearing him shaking and expecting to die at any moment or to have my father walk in and get shot." (*Craft Australia*, p. 22) These two experiences combined to make Cooper a lifelong pacifist and one highly critical of the role of weapons in contemporary society. He is equally critical of the ethos of power and violence so prevalent in contemporary American life.

These two experiences combined to make Cooper a lifelong pacifist and one highly critical of the role of weapons in contemporary society. He is equally critical of the ethos of power and violence so prevalent in contemporary American life.

Training

Cooper received both his BA in commercial art in 1966 and his MA in sculpture in 1968 from San Jose State College (now known as San Jose State University) where he studied with the eminent sculptor Fletcher Benton. He subsequently studied sculpture with ceramist Peter Voulkos at the University of California, Berkeley, where he was awarded his MFA in sculpture in 1969. Through Benton he received solid formal training in the logistics of creating large-scale sculpture. He also learned about how to work with dealers, collectors, and arts patrons—practical lessons that have served him well throughout his career. From Voulkos he learned of the fundamental importance of raw materiality to the fully developed and powerfully expressive work of art.

In 1967, in the midst of his studies at San Jose State College and at the urging of a friend, Cooper traveled to Los Angeles to see an exhibition at the Los Angeles County Museum of Art. Organized by LACMA's twentieth-century curator Maurice Tuchman, *American Sculpture of the Sixties* was a watershed exhibition that chronicled the most significant new directions in contemporary sculpture. The exhibition encompassed a wide

range of materials and varying approaches to sculptural form, from Edward Kienholz's provocative assemblages to James Turrell's sublime installations. However, according to Cooper, it was the extraordinarily well-crafted and quirky wood sculpture of H.C. Westermann that captivated him and that, ultimately, had the most profound and enduring impact on his work. He was also intrigued by the witty wood assemblages and fanciful acoustic-kinetic constructions of Stephan von Huene. (See interview in this publication.)

In the last year of his MFA program, Cooper served as an instructor at UC Berkeley and with this training and experience behind him, he secured a position at Foothill College in Los Altos Hills where he taught from 1969 to 1976. This was followed by a second teaching position at De Anza College in Cupertino from 1977 to 2004 and a one-year appointment as an instructor at California College of the Arts in San Francisco in 2004. Cooper is a superb teacher, revered by students and colleagues alike, but in 2005 he decided to forgo teaching and focus his attention on his artwork.

A Sculptural Odyssey

In exploring the artist's "sculptural odyssey," there are certain themes and motifs that recur over time and form an integral link between Cooper's earliest explorations and his most current work. Among these are his enduring interest in kinetic form, his fondness for figurative imagery, his acute sense of humor, and his sustained critique of power, violence, and greed.

In several of his earliest pieces, Michael Cooper investigates movement, both real and implied. In works that range from abstract kinetic forms with moving parts to actual vehicles, he explores and incorporates motion—sometimes literal, sometimes suggested—as an integral component of his work.

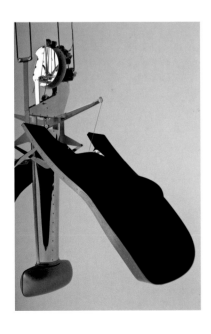

In *Ceiling Flapper* of 1968, motorized wings move up and down with a rather awkward self-consciousness, revealing and/or concealing a central metal element. The piece is at once a monumental mobile contraption suspended from the ceiling and a delicate organic form simultaneously suggesting avian, floral, and figural associations. In this early kinetic sculpture, Cooper introduced motion as a central element of his work.

In *Captain's Chair* of 1975, motion—unexpected, erratic, and highly unsettling movement—is a central element of the piece. In this breakthrough work, a chair is supported by wheels that are positioned to pivot around a turned wooden peg leg. This extravagantly curvilinear wooden chair, with its arcing crest rail and voluptuous stiles, is reminiscent of a traditional "captain's chair" to which the title refers. Installed on a sloping pine platform, however, this chair—which would normally offer tranquility and rest—suggests random motion and instability. *Captain's Chair* is doubly significant in that it is one of the artist's first major pieces comprised entirely of wood. It was exhibited in Los Angeles at the immensely influential exhibition *California Design '76*, where it garnered a rather ambivalent response from viewers. According to the exhibition's

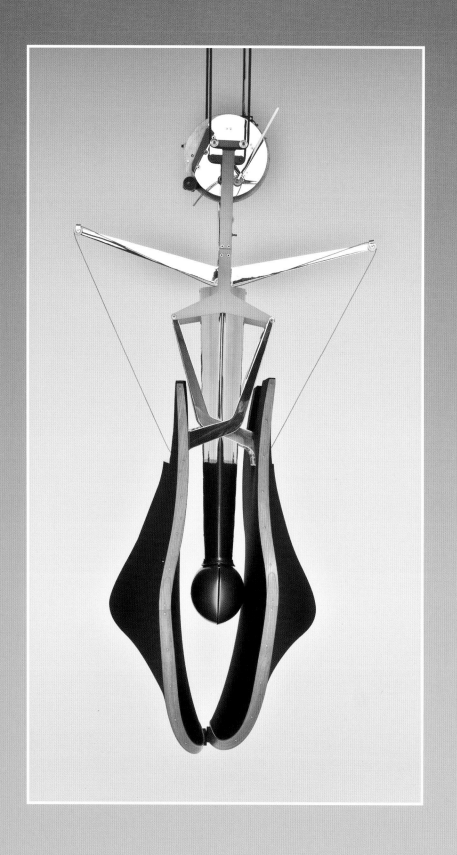

CEILING FLAPPER

1968

Aluminum, wood, fabric, motors, Plexiglas

67 x 72 x 28

Collection of Jacqueline Thurston

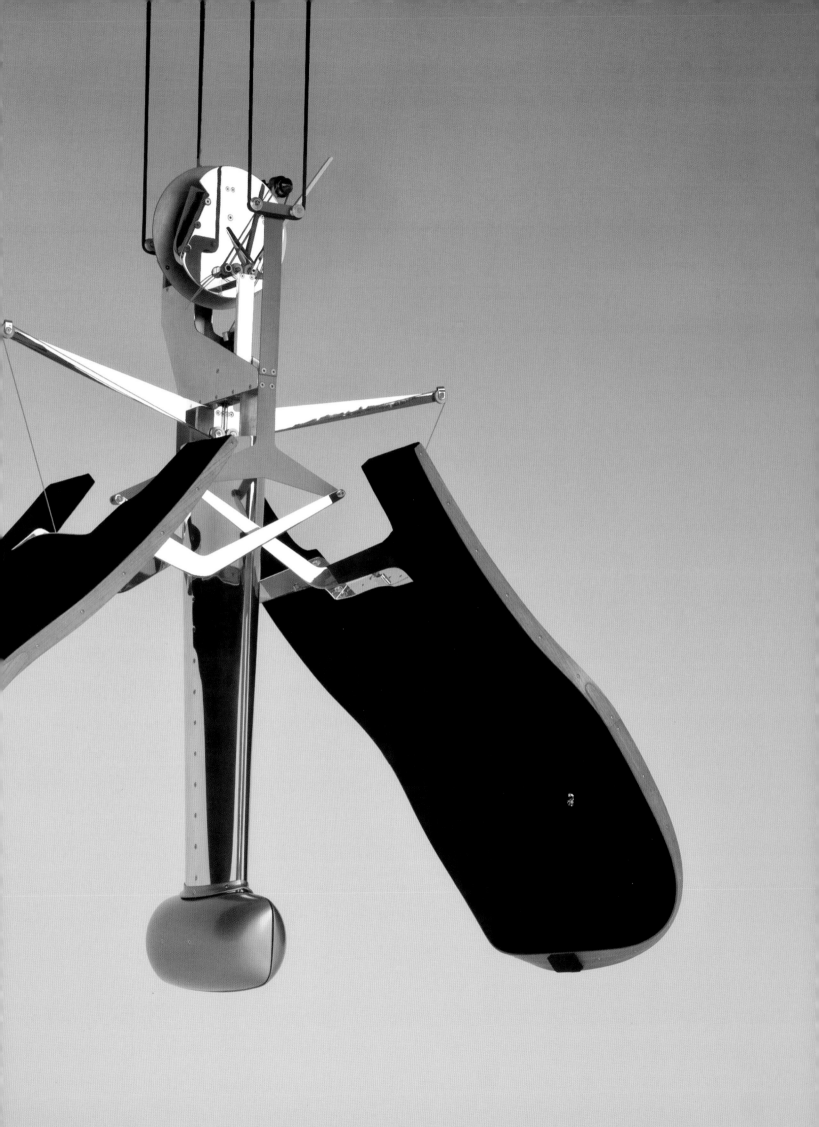

curator, Eudorah Moore: "*Captain's Chair*, built in 1975 and shown in *California Design '76*, swung several degrees across a sloped wooden deck from a pivotal peg leg. It wasn't a proper chair. It made people feel giddy, unsure of their perspective. It offended their sense of proportion and stability, but seduced them with beautiful workmanship and graceful parts. Many were angered to be lured into something they couldn't feel comfortable with as either art or as a chair, yet they couldn't resist actual contacts with the piece—a stolen stroke of one of its smooth curves or an angered shake of the whole thing. It was a very sophisticated piece..." (*Craftsman Lifestyle*, p. 107)

Soapbox Racer, also made in 1975 and featured in *California Design '76*, advanced Cooper's explorations of kinetic form one step further into a truly, if frighteningly, mobile conveyance. Originally made for a San Francisco soapbox derby organized by Cooper's former teacher Fletcher Benton, the vehicle is capable of great speed when pointed down a sloping incline. According to Eudorah Moore, this sculpture had a tail fin covered in "fine nylon mesh on a three-wheeled bentwood vehicle...At most twenty-eight inches high, the vehicle rolled on the finest bicycle tires made and could be driven by someone lying on his back going head-first downhill." (*Craftsman Lifestyle*, p. 107) When shown in the exhibition, the racer was perceived as an intriguing piece of surrealist-influenced sculpture. This work was illustrated on the cover of the *Los Angeles Times*' "Home Section" on Sunday, March 7, 1976 in an article promoting *California Design '76*. The caption on the image read: "An Adventure in Creativity."

Notably, Michael Cooper's wry sense of humor, which runs as a subcurrent throughout his work, is at play in both *Captain's Chair* and *Soapbox Racer*. The artist's work—a seemingly static chair that goes "mobile" on you when pushed and a lanky vehicular conveyance presented as a sculptural object in a gallery—often confounds expectations. It is this sense of defying the rules that gives Cooper's work its humor, wit, and power.

In the mid-1970s, Cooper began to explore a second great theme that would intrigue, inspire, and obsess him for more than thirty years—the association of handguns with male identity, power, and violence. The artist created the first in a series of all-wood "trainer tricycles" in 1976. In each exquisitely crafted piece, the body of the tricycle is a handgun, carved in wood and pointed in the direction the tricycle is moving. Implicit in these pieces—all of which reflect Cooper's enduring interest in vehicles—is a melding of childhood innocence and adult violence. Cooper seems to suggest that just as we are trained to ride a bike, we learn the hard lessons of violence in our youth. *Trainer Tricycle III* of 1993, made from a visually sumptuous combination of wenge and sycamore wood, represents the third in a series of four trainer tricycles made over the course of the artist's long and distinguished career.

In *Boy Scout Special* of 1977, Cooper continued his investigations into the puzzling relationship between childhood naiveté and adult violence. In this work,

a metal pistol is supported by a tall vertical column as it juxtaposes the elements of a handgun with the components of a multipurpose tool similar to the Swiss Army knife boy scouts carry on overnight camping trips. The artist's use of a black, anodized aluminum lends an even more menacing character to the sculpture than that seen in *Trainer Tricycle III*. The sharply defined cutting and drilling tools augment the sense of immanent violence intrinsic to this work.

About this same time, while continuing his parallel interests in implied violence and motion—manifest in various forms of wooden seating furniture—Cooper began to introduce more direct figurative references in his work. *Armed Chair* of 1977 is a seminal piece in which all these issues are at play. Interestingly, in this beautifully executed all-wood sculpture, an abstracted human torso forms the chair's seat just as human hands form the termination of its arms. This chair, like the trainer tricycles, is supported by three wooden wheels, but two guns are pointed at one another across the seat in a daunting face-off as hands firmly grasp the barrels of these loaded pistols. With its attenuated curving lines adding to the surreal mystery and power of the piece, *Armed Chair* is a veritable tour de force in craftsmanship and richly layered content.

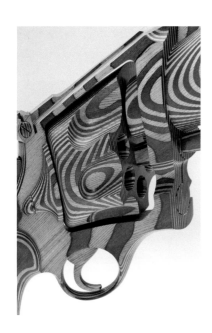

In Michael Cooper's work of the late 1970s, while maintaining his interest in handguns and violence, the artist began to explore issues related to scale and increasingly sumptuous materiality. In both *Gun in Greater Perspective* of 1978 and *Gun in Curved Perspective I* of 1980, he has stepped up the scale of his sculpture to remarkable proportions. In these works he also continued his interest in curvilinear form in sculpture that seems to twist and turn in space. Also, laminated pieces such as *Gun in Curved Perspective I*, which combines fine mahogany with ash, create a dazzlingly visual effect through the juxtaposition of light and dark woods.

In the mid-1980s, Michael Cooper gave free rein to his passion for the figure in work such as *Gayle* of 1985 and *Torso #3: Anne* of 1986. In both pieces the artist has explored the pure sensuality of the female figure, using his skill at carving and finishing wood to accentuate that beauty. Using paint in a gestural, nondescriptive manner, Cooper has created an arresting counterpoint to the smooth surface of the wood. Interestingly, he has also left the back of the figure in *Gayle* comparatively raw and unfinished to underscore once again the pure physicality of his medium.

Reflecting his increasing interest in the figure, he also introduced more fully developed figurative references into his chair and vehicular forms. In works such as *Overarmed Wheelchair* of 1989, a magnificently crafted piece combining laminated hardwoods and bicycle wheels, there is a certain sexual ambiguity to the figure. While the muscular arms that form the back of the chair appear masculine, the torso, thighs, and knees look more distinctly feminine. The hands that form the terminus of the swirling lines encircling the bicycle tires, however, are sexually ambiguous and undefined. This piece seems to mix feminine and masculine characteristics in comparably exaggerated proportions.

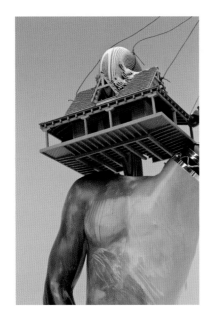

Cooper's explorations of figurative imagery led quite naturally in the late 1980s to an interest in self-portraiture. In 1989 he created an extraordinary mixed-media piece called *Self Portrait* in which a carved naked male figure stands on a small platform (covered in faux lawn) supported by three wheels. The nude figure with wing (or rudder) attached to its back, stands balanced on one natural leg. The other leg—a prosthetic limb—is comprised of various sculptural components and mechanical parts. The head of the figure is a house that looks very much like a miniature version of the home where Michael and his wife Gayle actually live. It is held in place by puppet strings suspended high aloft from a prosthetic arm also made up of mechanical and sculptural components. This multifaceted work is among the most complex pieces the artist has created. In its rich, albeit hermetic, narrative, *Self Portrait* foreshadows Cooper's explorations in *How the West was Won, How the West was Lost*, a monumental piece he created between 1977 and 2011.

Much of Michael Cooper's more recent work explores subjects and themes he has investigated throughout his career, though over the past decade, his forms have become increasingly elaborate and varied. His chair forms such as *Peaches* of 2004 and *Ruby* of 2010, with their long, flowing lines and combination of natural and man-made materials, have become extravagantly sensual. His all-wood sculptures such as *Gunrunner* of 2007 are utterly amazing in their meticulous detail and their breathtaking combination of dark and light woods. And, his grand, motorized "machines" such as *Ride* of 2008, which has the ability to leap up and down in space, and *Modified* of 2010, a riff on an old Adirondack chair that has the ability to careen down the highway at sixty miles an hour, have taken Michael Cooper's imagination and technical facility to unprecedented new levels.

Finally, *How the West was Won, How the West was Lost,* which the artist has worked on for over thirty years, is truly Michael Cooper's magnum opus. Its exploration of power, greed, and the pursuit of oil has become even more relevant today in the wake of the BP oil spill in the Gulf than it was when the artist began this piece in the 1970s. As in much of his work, Cooper has incorporated references to childhood innocence—in this case by using actual toys in the piece—to underscore how the playthings of our youth become the weapons of our own destruction when misdirected in our adult years. *How the West was Won…* is, at once, an astoundingly complex kinetic machine and a morality tale denouncing greed, lust for power, and the pursuit of wealth at all costs.

In its presentations of familiar, iconic forms such as hot rods, children's toys, and guns, Michael Cooper's work is, at its most fundamental level, widely—perhaps disarmingly—accessible. The familiarity of his subjects, along with the artist's awe-inspiring handling of his medium, engage the viewer in the set of ideas Cooper explores in each work. However familiar, there is something wildly preposterous in his work, something that ignites the imagination and confounds the commonplace.

The familiarity of his subjects, along with the artist's awe-inspiring handling of his medium, engage the viewer in the set of ideas Cooper explores in each work. However familiar, there is something wildly preposterous in his work, something that ignites the imagination and confounds the commonplace.

It is this combination of the familiar and the disquietly unexpected that gives Cooper's work its power and its resonance.

Cooper's approach to his materials is remarkably unrehearsed and intuitive. Yet while never held hostage to his preliminary ideas and plans, he does occasionally make drawings and sketches as he develops an idea for a piece. These drawings offer insight into his process. The artist's solid grounding in mechanical drawing informs and gives shape to these fascinating studies.

On the nontraditional nature of his furniture forms, Cooper has stated: "I'm not interested in straight furniture. I can't make things with four regular legs. If it's got three wheels and a peg joint, then that's a regular chair for me." (*Woodwork*, p. 74) About his process, he has stated: "It's a matter of overcoming limitations with the tools. You do a certain amount of carving with a mechanical process, then you use an air tool, a hand tool and one week later you have a carburetor. For me, the fun part is discovering what the process is that's going to make it work." (*Woodwork*, p. 76)

On the obsessive nature of his work, Cooper has said: "You can't do anything the least bit technical with a little bit of time here and a little bit of time there. It requires a lot of discipline and nothing happens until you've got a couple hundred hours into it. I set myself a problem and a time limitation. I've got my mind and wits to carry me through, but I like that kind of competition with myself." (*Craftsman Lifestyle*, p. 110)

Michael Cooper: A Sculptural Odyssey, 1968–2011 documents the career of a unique and disarmingly original Bay Area artist through eighteen of his most exquisitely crafted and thought-provoking works. We sincerely hope that this exhibition will engage the public and stimulate young artists to produce provocative new work exploring equally compelling ideas and issues.

Harold B. Nelson, Guest Curator

Harold "Hal" Nelson is curator of American decorative arts at the Huntington Library, Art Collections, and Botanical Gardens, San Marino, California.

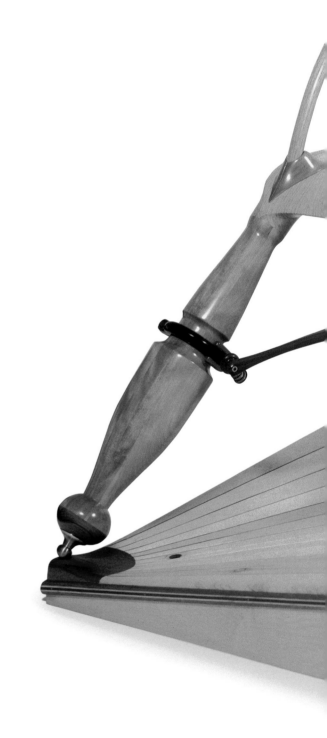

CAPTAIN'S CHAIR

1975
Solid and laminated hardwoods
38 x 44 x 44
Salvador Dali Museum, St. Petersburg, Florida
Photo: Howard Photographics

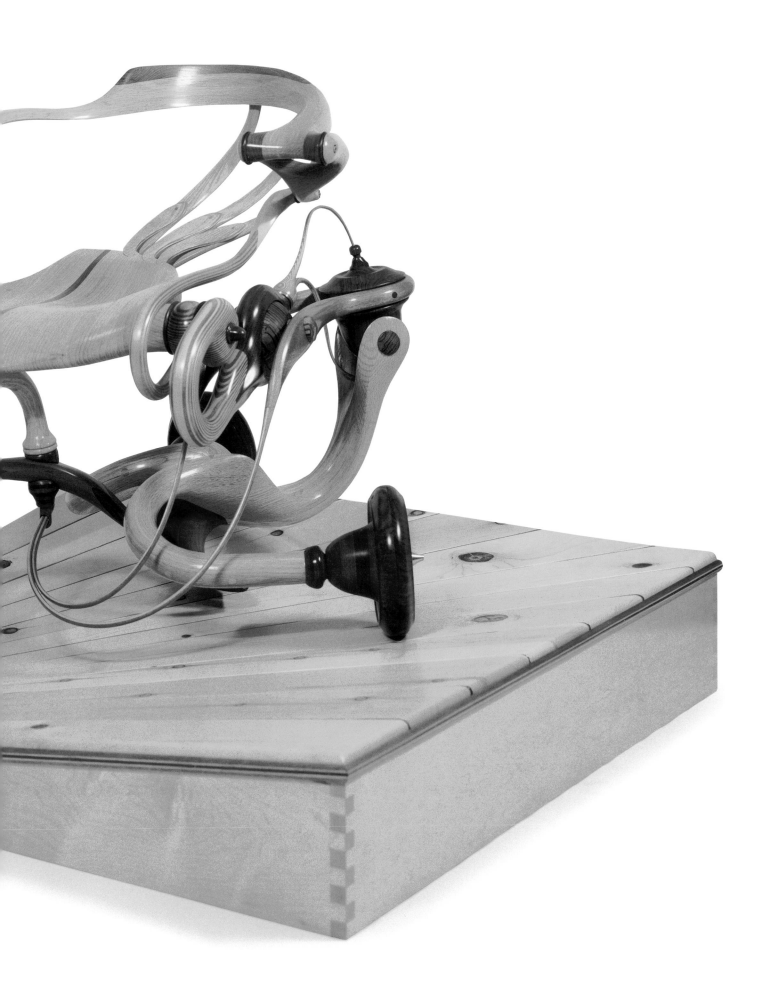

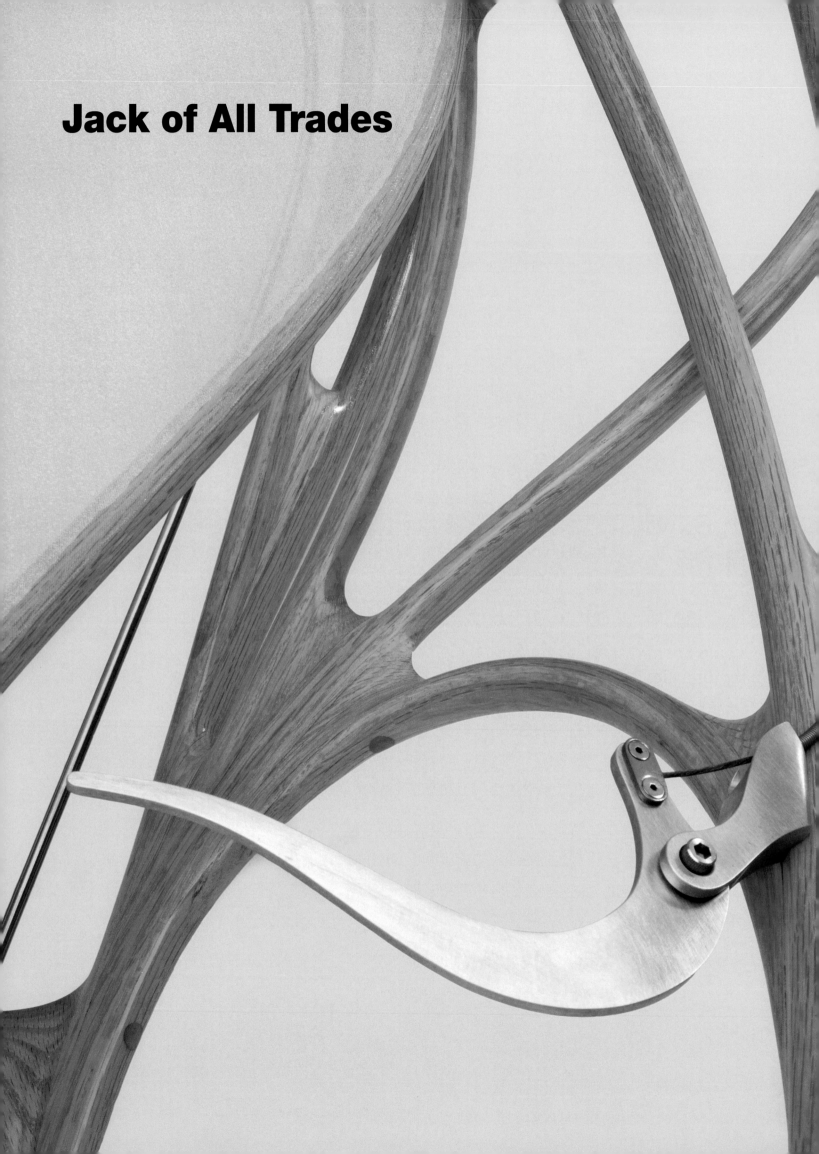

Jack of All Trades

It's taken a while, but Michael Cooper's work finally looks contemporary again.

The last time this happened was in the 1970s, when his singular vision was cohering. At this point, kinetic sculpture had just entered the mainstream—thanks to the efforts of artists like Jean Tinguely, George Rickey, and Cooper's own teacher Fletcher Benton. The art world was full of breathless attempts to merge sculpture with engineering, most notably the exhibition *Art and Technology*, which opened at the world's fair in Osaka in 1970 and then traveled to the Los Angeles County Museum of Art. Many artists, including figures as eminent as Robert Smithson and Alice Aycock, seemed to be trying to win an imaginary science fair. Their works might be visually arresting, and as baroque as a seventeenth-century automaton, but they spoke the language of a prototype or model, as if the laws of physics themselves had sprung into material form.

The '70s were also a decade when the craft movement's long affair with skill reached its apex, a phenomenon that Edward S. Cooke, Jr., has dubbed "technical fetishism."[1] Glassblowers were steadily rediscovering the techniques of Renaissance Venice; ceramists were creating hyper-real trompe l'oeil objects simulating other materials; and jewelers were investigating the possibilities of granulation, enamel, and patination. In the world of woodworking, which Cooper himself occupied, makers were attracted to demanding techniques such as steam-bending, laminating, and carving. The forthright, Scandinavian-derived manner of an earlier generation (as realized by makers like Sam Maloof and Art Espenet Carpenter) gave way to a diversity of expressive styles, in which the full repertoire of cabinetmaking skills were put on display. Jere Osgood's tapered laminates, Richard Scott Newman's refined historicism, and especially Wendell Castle's postmodern trawl of idioms, each more difficult to achieve than the last, all marked a departure for the field.

Michael Cooper's work has affinities with both of these trends. He has also mined the intense, perfectionist aesthetic of Californian hot rod culture, as well as the more longstanding (but equally exacting) traditions of scientific instrument makers. But as an artist, he has always been more than the sum of these many parts. You would not mistake Cooper for a kinetic sculptor, a conceptual artist, a studio furnituremaker, or a gearhead, though he adopts all of those roles from time to time. Nor could he be taken for a "visionary" or "outsider" artist, a somewhat euphemistic term that was also gaining popularity during the 1970s. While his work has some of the earmarks that one associates with outsider art—a seemingly inordinate attention to detail, an over-elaboration of form in relation to function, and a fascination with intense, sometimes violent imagery—Cooper pays far too much attention to what is going on around him to be categorized in this way.

You would not mistake Cooper for a kinetic sculptor, a conceptual artist, a studio furnituremaker, or a gearhead, though he adopts all of those roles from time to time. Nor could he be taken for a "visionary" or "outsider" artist, a somewhat euphemistic term that was also gaining popularity during the 1970s.

Of course, there is no reason that art should have to be categorized at all. For a couple of decades there, Cooper may have seemed merely eccentric. Now he seems prescient, precisely because of the transient nature of his creativity. The clean-cut institutional boundaries of the 1970s (particularly the dividing lines between studio craft, fine art, and design) have eroded to the point that they are nearly indiscernible, making his longstanding nondisciplinary stance seem ahead of its time. Many artists now operate as Cooper does—like itinerant tinkers, picking up skills and forms as they seem warranted according to some private narrative. In younger artists, this indiscriminate attitude often comes across as a limitation. Art schools now tend to de-emphasize the teaching of skills, providing maximal lateral and theoretical freedom, but at the cost of professional training in a given set of techniques. A lack of formal control is the result. Rare today is the artist working in any material who seems to be pushing it around, rather than vice versa. Even the best of the "tinker" artists on the contemporary art scene—Tim Hawkinson, Sarah Sze, and Urs Fischer spring to mind—are usually content to steer clear of traditional skill bases, instead opting for a rough-and-ready garage aesthetic, or (as in Fischer's case) recourse to hired help.

Cooper stands out vividly against this skill-starved backdrop. His work calls to mind the observation made by anthropologist Alfred Gell:

The enchantment of technology is the power that technical processes have of casting a spell over us so that we see the real world in an enchanted form. Art, as a separate kind of technical activity, only carries further, through a kind of involution, the enchantment which is immanent in all kinds of technical activity.[2]

Gell argues that a power inheres in the asymmetry that exists between the skilled fabricator of an artwork, and the viewer of that same work. This means that, at some basic level, art's potency resides in the *incomprehension* of the viewer. Cooper's sculptures could almost have been designed to demonstrate that principle. Not only are they awe-inspiring in their craftsmanship, they are also "enchanted" on the level of form—often involving a collage of different techniques in wood and metal forming, and achieving a compositional intricacy that defies easy understanding. Cooper's elaborate creations refer to technologies outside themselves, too, through a principle of material substitution: an exhaust pipe made of purpleheart, or a gun made of laminated plywood. The result is a kind of technical sublime, an onrush of surplus skill that not only functions as its own sort of spell-casting, but also summons the magical qualities of mechanical technique in general.

In this respect, Cooper's work relates in important ways to the attitude that makers of all kinds are taking to technology. Even in the 1970s, when prototyping served

as a model for artists, there was anxiety attached to the prospect of an art/science alliance. After all, it was technology that was driving the Cold War, not to mention the hot one in Vietnam. Today, in an age of digital as well as industrial overproduction, attitudes are even more ambivalent. Craft is often treated as a kind of antidote to the massively scaled, fluid, and dematerialized effects that our information economy tends to propagate. Thus, in the DIY movement, we have knitting, handmade clothing, and puppetry employed for the purposes of antiglobalist protest. The so-called steampunk subculture, originally inspired by science fiction, revolves around retro-styled objects (steam-powered laptops and the like) that are assertively handmade, usually from brass, wood, glass, and other low-tech materials. Both DIY and steampunk bear superficial resemblances to Cooper's work. But while they adopt an escapist pose in relation to technology, Cooper addresses it directly. He may have a humanist's distrust of advanced weaponry, but he also has a mechanic's love of the moving part.

So craft and technology are not opposed in his work, but rather mapped onto one another. In this way Cooper's sculptures are perhaps more comparable to the forms of craft being undertaken at places like the MIT Media Lab. There, a group of engineers led by Neil Gershenfeld has initiated the building of small-scale, computer-powered, globally distributed workshops called Fab Labs, where the public is invited to engage in hands-on, computer-supported making. The goal is to allow "anyone to manufacture (almost) anything, anywhere in the world."[3] The precept of the Fab Labs is a corollary to Gell's: if skill constitutes a sort of power, then distributing skill is inherently empowering. Cooper is not in the business of proliferating his hard-won techniques across the globe, like Gershenfeld, nor does he go in much for the advanced open-source technology—CAD drawings and rapid prototyping machines—that form the heart of a Fab Lab. But his work certainly exemplifies the skill-led, recursive research patterns that contemporary designer-engineers like Gershenfeld have adopted as a methodology. Each of Cooper's sculptures is an adaptation, an extension, a "version" (to use a favorite MIT term) within an ongoing process of development. The ongoing adjustment of fabrication accounts for a large portion of the change: again and again, he returns to the racer and the chair as problems to be puzzled through—but never solved.

Cooper's *Self Portrait* as a self-operated puppet serves as an apt summation of his career. A work of many parts, collaged together in madcap style, it would seem ramshackle if it were not for its maker's customary exquisite craftsmanship. With its palette-shaped wing, it suggests another jack-of-all-trades, the Renaissance artist and inventor Leonardo da Vinci, whom Cooper might well want to claim as an ancestral figure. Indeed, the two men could be seen as bookends of a certain intertwined history of art and engineering.

Leonardo lived long before the disciplinary walls between those two arenas of practice were erected in the first place; Cooper grew up in the shadow of those walls, but chose to ignore them. Now, as that disciplinary architecture recedes into the distance, invention floats free. It is Cooper's signal contribution to remind us at this permissive time, when artists are rightfully expressing their right to do whatever they want, that it still helps to know what you're doing.

Glenn Adamson

Glenn Adamson is deputy head of research and head of graduate studies at the Victoria and Albert Museum, where he leads a graduate program in the history of design.

Notes:

1 Edward S. Cooke, Jr., et al., *The Maker's Hand: American Studio Furniture 1940 – 1990* (Boston: Museum of Fine Arts Publications, 2009).
2 Alfred Gell, "The Enchantment of Technology and the Technology of Enchantment," in Coote, ed., *Anthropology, Art, and Aesthetics* (Oxford; Oxford University Press, 1992).
3 Neil Gershenfeld, *FAB: The Coming Revolution on Your Desktop: From Personal Computers to Personal Fabrication* (New York: Basic Books, 2005).

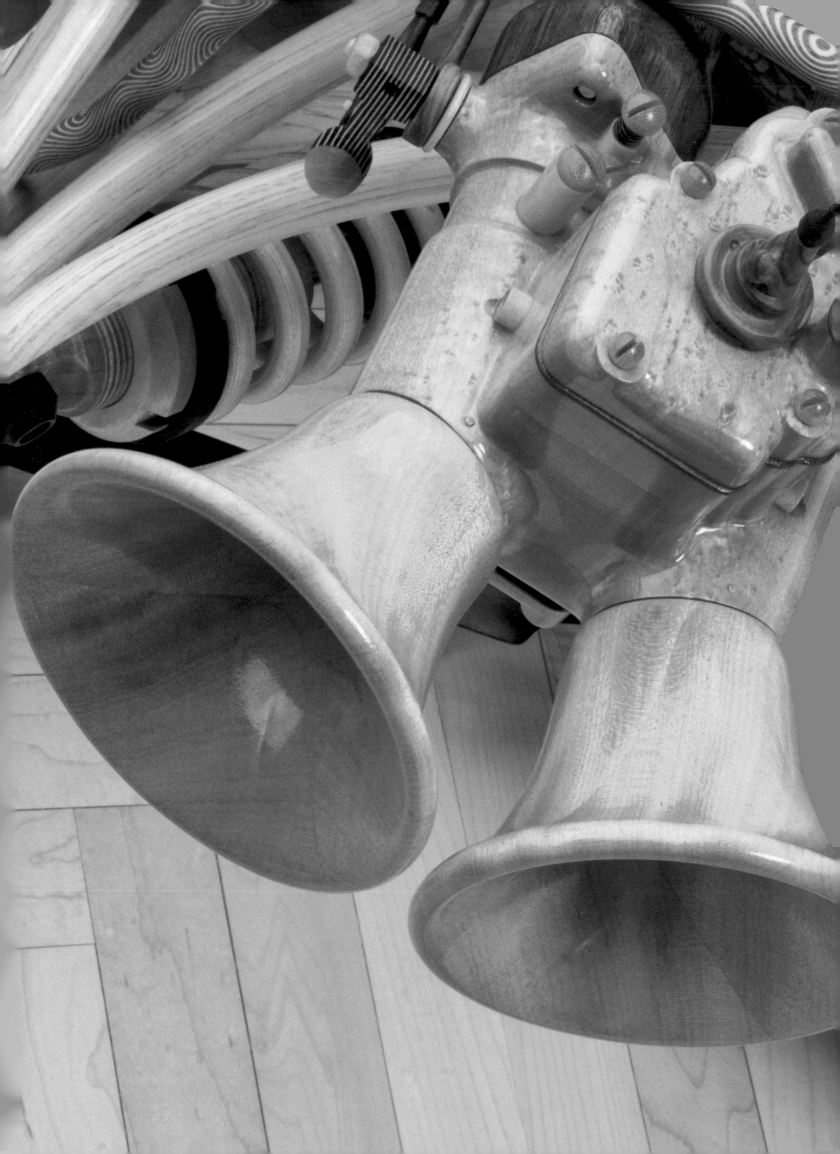

SOAPBOX RACER

1975
Laminated oak, aluminum, Plexiglas, bicycle wheels
28 x 50 x 144
Collection of Richard Wickstrom

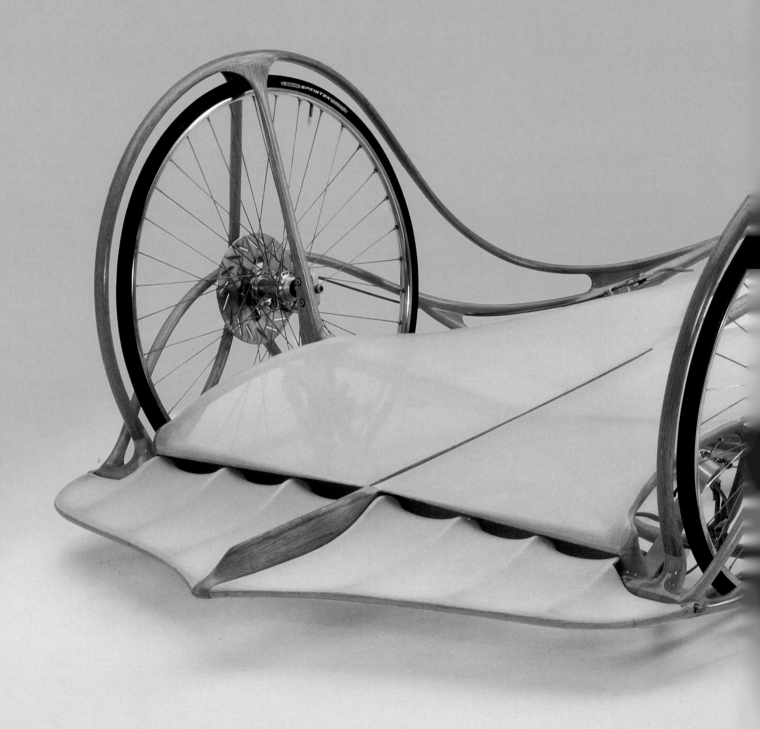

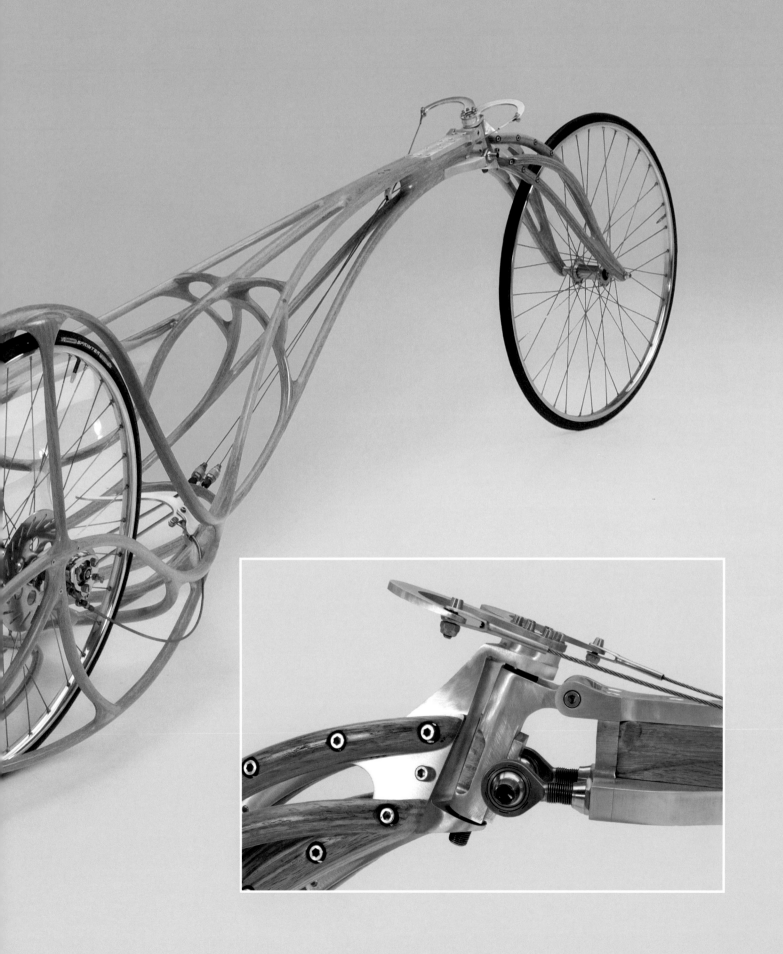

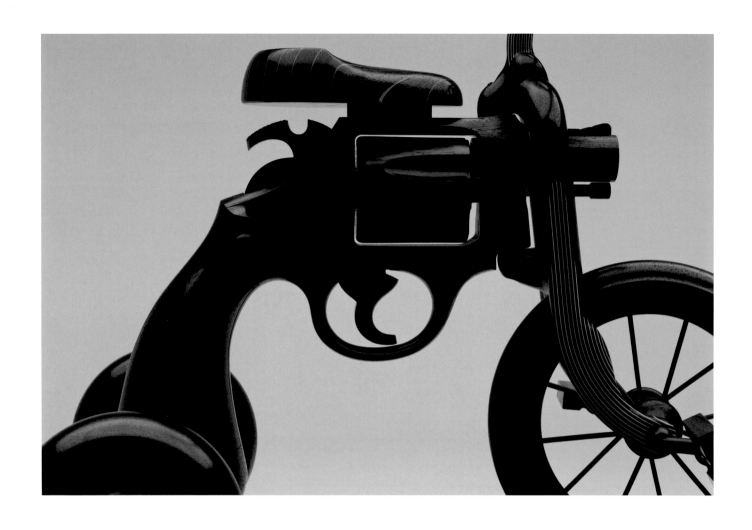

TRAINER TRICYCLE III

1993
Wenge, sycamore
29 x 30 x 26
Collection of Dennis and Kathy Varni

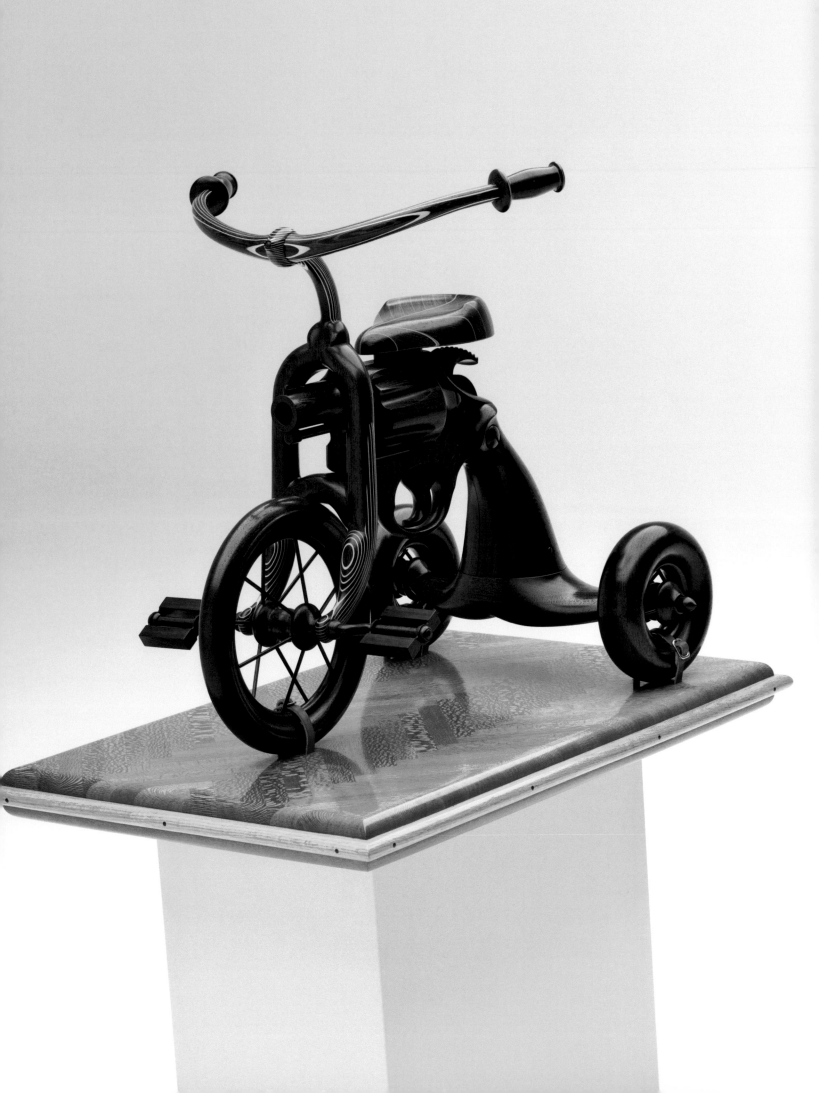

How'd he do that?
A Brief Guide to the Work
of Michael Cooper

Surveying a roomful of Michael Cooper's sculpture, a viewer can easily be overwhelmed by the riotous profusion of materials and shapes. But after your eyes have settled on any of the myriad details in this work, the question that inevitably follows is: How did he do all that? Since Cooper's intention is to delight rather than mystify, deconstructing some of his pieces can only enhance our appreciation of the work. There are, in fact, enough techniques deployed in almost any one of these sculptures to fill separate training manuals for woodwork, metalwork, and mechanics; what follows is of necessity only a sampler.

Cooper developed his skills through his experiences growing up in Lodi and his work and studies at San Jose State College and UC Berkeley. Raised in a farming community, he absorbed from an early age the culture of improvisation and make-do in building and repair. By the time Cooper finished his MFA at Berkeley, he had a vision of the work he wanted to do, a facility for working wood and metal, and the confidence that he could meet any technical challenge he set for himself. As it turned out, the challenges would be many. For although Cooper uses his skills as a draftsman throughout the process of designing and building, his preferred approach has always been to leave many of the details unresolved until the moment is at hand, which can create exciting opportunities—and unforeseen difficulties. Three other qualities would prove indispensable to Cooper in this seat-of-the-pants approach: patience, tenacity, and a good sense of humor.

II

Over the years, Cooper's kinetic sculptures have employed increasingly sophisticated and complex mechanical movements, from the relatively straightforward motor-cable-pulley mechanism of *Ceiling Flapper* to the microprocessor-controlled pneumatic system that animates *How the West was Won, How the West was Lost*. Likewise, the mechanics of the hot rod in *Modified* have been revved up to full throttle in the eight gas engines working in tandem to power *Ride*.

The construction of these kinetic pieces relies heavily on a skillful use of steel and aluminum. Some shapes, such as the stamped steel spheres and hemispheres that show up in several of his sculptures, Cooper gets ready-made through his arsenal of mail-order parts catalogs. Others are slightly modified stock parts that he TIG-welds to form his desired shapes; tungsten inert gas welding, when done well, is a very clean way of joining aluminum or steel. An elaborate sculptural element such as the chromed tubing that haloes *Ride* involves a laborious fabrication of smaller parts. In constructions like this, where the tolerances are minute, Cooper works from detailed mechanical drawings. To fabricate the long, tapering tube, dozens of pieces of sheet steel were meticulously cut from paper patterns, then rolled to create small tapered tubes of precisely differing diameters. These were bead-rolled and seam-welded to create a flared joint at each end, and finally welded together one to the next.

The other metalwork that Cooper does, most evident in *Boy Scout Special*, involves shaping solid blocks of aluminum. This is accomplished primarily on two machines:

a metal lathe and a vertical milling machine. A metal lathe is the tool of choice for turning metal blocks to create rods and cylinders. A milling machine is similar to a drill press, using interchangeable cutters that are held in a collet, but unlike a drill press, where the workpiece is held stationary while the rotating bit is lowered into it, milling machines can also move the workpiece radially against the rotating cutter, which cuts with its sides as well as its tip. Using a large assortment of tool bits and operating to tolerances of less than a thousandth of an inch, a mill is capable of shaping and texturing a relatively soft metal like aluminum to whatever form or pattern Cooper fancies. Individual parts (a gun's trigger, hammer, barrel, etc.) can then be fastened or welded into subassemblies and then into the whole.

III

In 1975, having labored for several years on two large kinetic sculptures—both fairly rectilinear metal constructions—Cooper shifted gears and turned to wood. At the same time, his work became extremely curvilinear. These two changes went hand in hand: the working properties of wood are well suited to making curves, and curvilinear shapes, with their suggestion of animation, are enhanced by the organic character of wood. The results that year were three pieces: *Music Stand*, *Captain's Chair*, and *Soapbox Racer*. The latter two were "breakout" pieces, establishing two significant series (chairs and vehicles) that have carried through to the present.

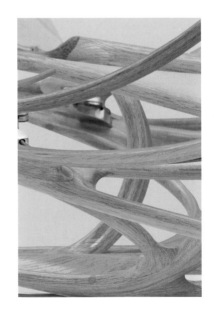

The long graceful curves in these pieces were achieved by a technique called bent lamination. Because wood has linear grain and is not uniformly strong in all directions, simply cutting a curve into solid wood will,

when cutting beyond a certain amount of arc not along but across the grain, make the wood susceptible to fracture. To create the long, slender, curved parts of a piece such as *Soapbox Racer*, the solution instead is to use long, thin, flexible strips of wood of uniform thickness, usually about one-sixteenth to one-eighth of an inch, apply a film of glue to all mating surfaces, and stack them together in layers (laminations) that can then be bent to the desired shape and clamped on forms until the glue dries. A variation on this technique is simply to use rope or rubber tubing tightly wrapped around the laminations to apply the clamping pressure required for gluing. This variation makes it possible not only to bend but also to twist the material like a noodle, free-form, and the complexity of the curve is limited only by the number of helpers' hands available to manipulate the material. The resulting bends or "bent laminations" are strong and rigid. The thin strips used for the laminations can be all one species of wood (red oak for *Soapbox Racer*) or several (alternating bands of maple and mahogany for the backrest of *Ruby*). Another variant of the laminating process is stacked lamination—simply to build up mass by stacking together multiple thicknesses of wood. Here, too, this could be all one species (the wenge body of *Trainer Tricycle*), or could be several in varying thicknesses to create a decorative effect (the seat of *Ruby* is a fine example).

After these glue-ups have set, Cooper further shapes the forms with an array of handheld power tools, electric and pneumatic grinders, and sanders using progressively finer grits of sandpaper. For precision fine shaping he uses a series of hand rasps and files.

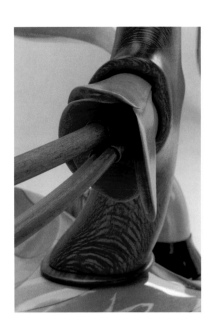

IV

What impresses most about Michael Cooper's work is that, though his craftsmanship is formidable, technique never dictates content; it is always the reverse. Combined with his penchant for ad-libbing details, this has resulted in some truly inventive solutions to accomplish his designs. Such is the case with the convoluted exhaust manifold at the center of *Gunrunner*, which was created by an entirely different process of curve making.

Using a bandsaw, Cooper first cut a series of donut shapes from a flat square block of wood. He began by cutting the outer circumference, then cut at a right angle into the resulting disc and proceeded to cut an inner circle until a donut shape could be lifted free. He then repeated the process, making three or four donuts of decreasing diameters from each block of wood. He repaired the cut through each donut by gluing a sliver of wood into the kerf. Using a spindle sander and disc sander, he then cleaned up the shapes inside and out. To give the donut a round cross section he used a round-over bit in a router table, working all edges of the curve. Each piece was next chucked on the lathe, using a special padded fixture for holding it, and sanded to a fine finish. The donuts were then cut into varying segments of a circle—45°, 90°, 120°, and 180°. Finally, both ends of each segment were carefully drilled and tapped, using his vertical mill, to accept the threaded rod he would use to connect the segments.

The making of all these parts took more than a week, and only then did the actual construction begin. Like playing with a set of Tinkertoys, Cooper proceeded to create his convolutions, joining one segment to the next with threaded rod. He interchanged and moved the parts around, exploring possibilities and options, until he was satisfied with a final layout. He then carefully marked each piece for position, dismantled the entire arrangement, and then reassembled it, this time using epoxy in addition to the mechanical fasteners. Once the entire piece was together, it was extremely strong and rigid. He sanded away any slight misalignments, blended all his curves, and finished with multiple coats of tung oil and urethane.

V

Michael Cooper's 1979 sojourn in Rome as a Fellow of the American Academy deepened an interest that had begun a few years earlier. In 1977 he had completed *Armed Chair*, in which he incorporated two carved hands, his first attempt at figurative work. In Italy he spent a year surrounded by classical and Renaissance sculpture. By 1980 he was back in California, resolved to continue with figurative work.

Traditional woodcarving is based on the use of many specialized steel-edged tools that are either pushed through the wood by hand or struck with a mallet. A carver's tool roll typically contains dozens upon dozens of gouges and chisels in all shapes and sizes. A carver must understand and master the use of all these tools, and develop a keen feel for handling all the variability of wood grain. Cooper has never been a traditionalist in his woodworking, however, and his approach to carving was no exception. His solution was typically ingenious and ambitious: he would bypass all the hand tool work and

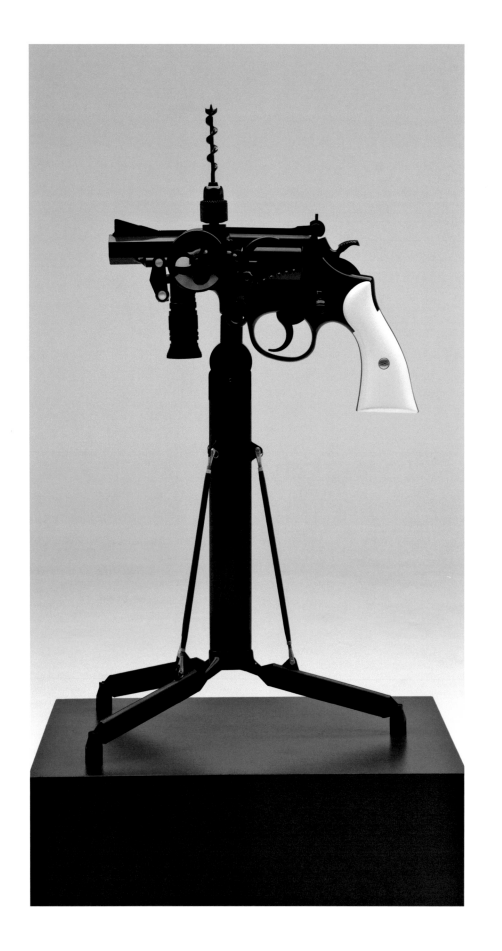

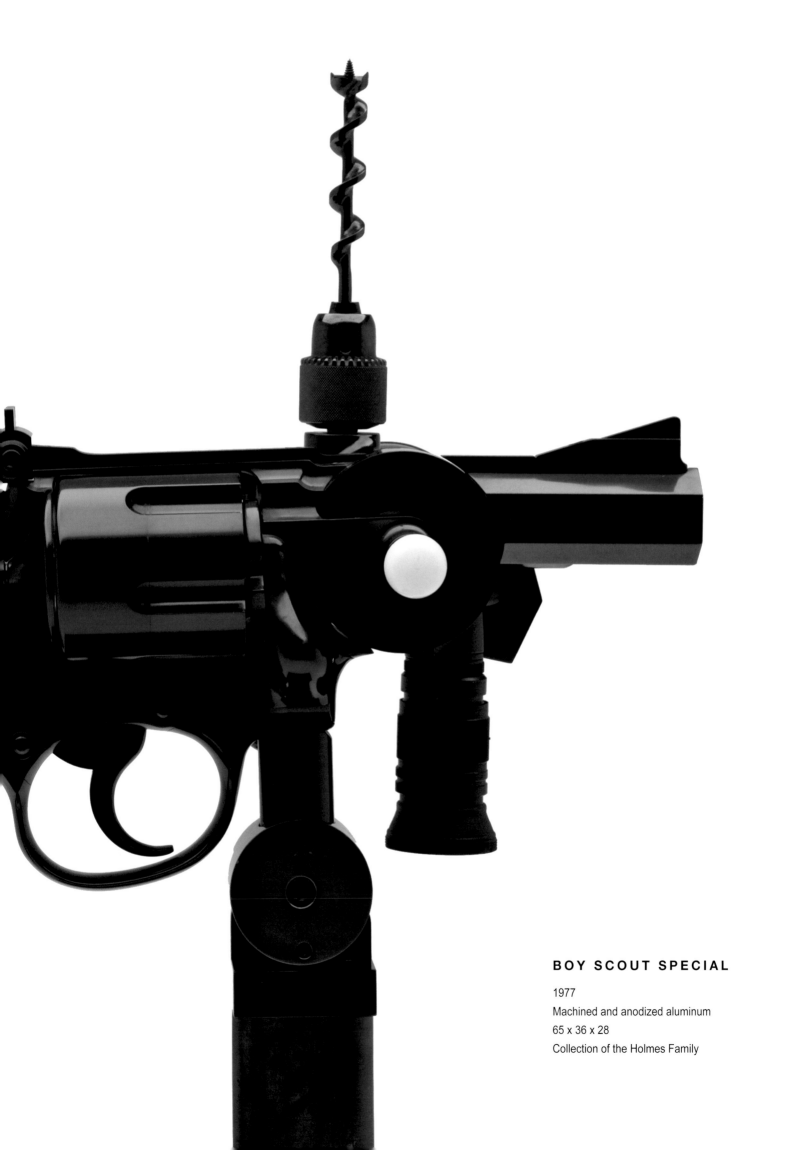

BOY SCOUT SPECIAL

1977
Machined and anodized aluminum
65 x 36 x 28
Collection of the Holmes Family

would instead design and build an enormous mechanical duplicating machine.

The concept of Cooper's duplicator will be familiar to anyone who has ever watched a locksmith make a copy of a house key. Two workstations sit side by side; on one is placed the original, on the other a blank. A cutting tool is rigidly attached by means of a linkage to a stylus, exactly the same distance apart as the two pieces are set from each other. As the stylus is traced over the contours of the original, the linkage moves the cutting tool to create an exact copy in the blank. Cooper spent six months building his machine, a fifteen feet wide by eight feet deep by eleven feet high heavy steel framework supporting a rigid but fluidly moving linkage, with a steel rod stylus at one end and a heavy-duty router with cutter at the other. His originals were life-size plaster molds created from people; his blanks were large stack laminations of maple (for *Torso*) or sugar pine (for *Gayle*).

VI

Typically, though, what began for Cooper as a series of pieces that he could create at a faster pace turned into something else, as his restlessness pushed the work in a more ambitious narrative direction. The results were two major pieces, each taking almost a year to complete, and exhausting both the artist and the series. Every detail in *Self Portrait* reads like a signifier of Cooper's life and work. Made of wood, metal, and found objects, referencing mechanical action and kinetic motion, constructed using the full range of his technical apparatus, the figure embodies in every part both family history

(for example, a crippling hand injury to his father) and personal struggles with his art (as in the question mark being pulled from his head/home). Like a rudder or a wing, a delicate mechanism—an artist's palette—is there to propel and guide him on. But the crucial cable linkage has a knot in it: Will he crash and burn? The year was 1989, and happily for us all, his good humor, artistic curiosity, and sheer inventiveness prevailed. Twenty years later, Michael Cooper and his work still power on.

John Lavine
John Lavine is an editor, writer, and woodworker. He was the editor of *Woodwork Magazine* from 1997–2008.

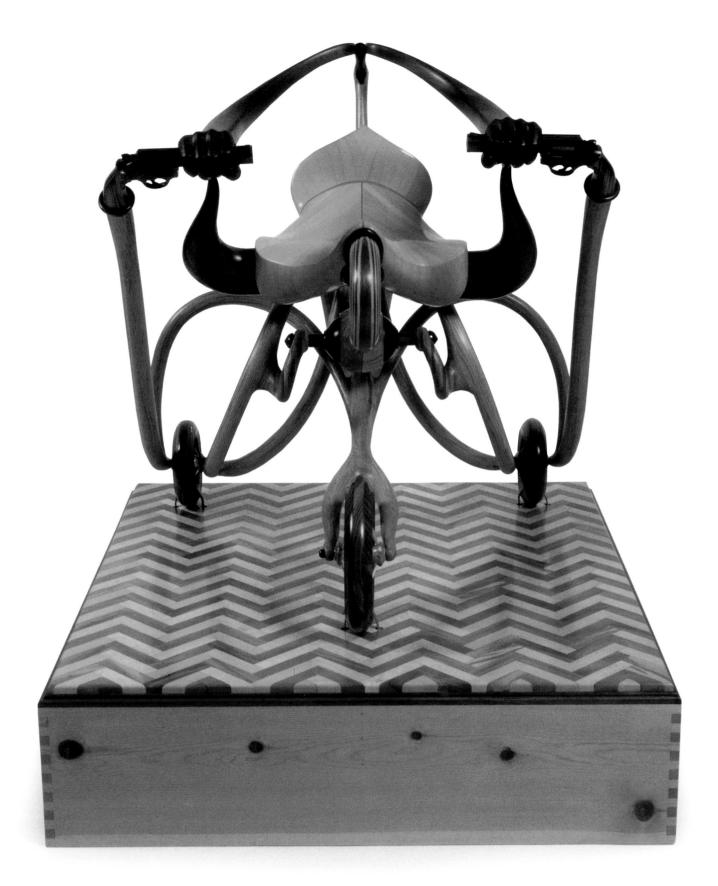

ARMED CHAIR

1977
Laminated hardwoods
57 x 48 x 52
Collection of Kia and David Hatch
Photo: R. J. Muna

Michael Cooper
A Tribute

Michael Cooper is an indigenous California product, as singular as the redwoods near which he was brought up. Just as an endemic plant, at home in its natural environment, has a basic vitality, so Cooper's work is full of palpable verve and zest. It is highly personal, though wonderfully unself-conscious, devoid of self-important posing, yet masterful and complex. He was imbued with "infusion learning"—knowledge and appreciation of process—through his relationship with his grandfather and uncle. And Cooper was in college at a heady time, studying with charismatic makers, a stimulating and exciting addition to his expanding horizon. Thanks to the GI Bill, art departments were humming, and art teaching jobs were available. Art was being rethought, boundaries were being pushed, and accepted concepts were being revolutionized. In the college environment the age-old craft materials were being explored beyond function for their purely aesthetic and expressive potential.

To go back to my botanical analogy, in sites where there has been a collision of continental plates, one finds great richness of plant varieties. So when the "craft plate" coincided with the "art plate" at midcentury, it produced multitudes of dazzling varieties of expression, using what had been considered craft materials, toward purely conceptual ends. This climate—coupled with Cooper's own roiling and fecund brain, added to his do-it-yourself desire to try to do the undoable—constituted the launching pad for his career, which has been marked throughout by constant high discipline, impeccable craftsmanship, and enormous exploration of ideas, both technically and conceptually. Each of his works is a tour de force of craftsmanship. He has done the undo-able, and woodworkers everywhere are in awe of his skill, sometimes so much so that the expressive potency of his idea, of his concept, becomes muted in the admiration of that skill. His works are not only abstract philosophical allusions but also direct and very personal statements of his values.

We tend to try to categorize in order to more easily weigh and compare. Cooper's work eludes categorization. It has a deeply human quality about it that lures you in. You are seduced by the beauty of the materials and by the technical skill with which they are manipulated, yet sometimes amused by the absurdity of the image. Because it is truly original, you are held beyond a cursory glance. This work doesn't fit into any of the usual categories. Work that is original has a certain privacy about it, an inherent resistance to being slotted and read too easily.

There is a surreal quality to many of his explorations, as if he had moved beyond the limitations of reality to a world of other dimensions and possibilities, a dream world in which familiar letters form a new language. I so clearly remember the first time I saw the Captain's Chair in the '70s. It was like a charge, a moment of electric excitement. This superbly executed wood sculpture—a masterpiece indeed, surreal, visually and conceptually challenging, executed with such skillful and ideational panache—made you smile, then wonder,

think. It made you return to reassess. It was filled with contradicting messages: When is a chair not a chair?; I'm a chair, but don't sit on me!; implications of great mechanical capabilities that clearly did not exist. Yes, it was a masterpiece of the art of woodworking. It was more; it was an important piece of art, uniquely expressed, cerebral, elusive, and potent. To me, the soapbox racers fall in this same category: a dream of speed, a memory of function, a wry wit, a beautiful and elegant sculptural object.

Cooper is an innate explorer, a responder to challenge. He exemplifies to me the midcentury revolution in the crafts, the push-pull of art and craft, and the redefinition of each in the process. It is not the purpose of this essay to describe individual works, but rather to place this unusual and very talented artist in a firm exposition and relationship with his peers, and with his times; to shine a light on and delineate the strongly individual path he has chosen, and within that context, his unquestionable merits as a sculptor.

Eudorah Moore
Eudorah Moore was curator of design at the Pasadena Museum of Art from 1962 to 1977. She curated four landmark California design exhibitions held at the Pasadena Museum of Art between 1962 and 1971, and the final exhibition in the series that was held in 1976 at the then newly opened Pacific Design Center.

A Conversation with Michael Cooper

The following was condensed from an interview with Michael Cooper that took place at his studio and home in Sebastopol on September 10, 2010.

When did art become a serious interest for you?

In college in my sophomore year I took one art class. I really enjoyed it and thought, "I like drawing and working with my hands and doing art" even though I hadn't done anything like that in high school. I thought about taking commercial art courses at the junior college, then actually did when I transferred to San Jose State where I got my degree in commercial art and illustration. In my senior year of the program I became more and more interested in what some of the teachers were doing who were sculptors, and I started going to San Francisco to see shows.

What was it like growing up in Lodi and did that influence your work?

I think it did, because I grew up in a pretty ideal time for an American boy, roughly the '50s. Lodi was a town of about 18,000 then, and we were about three miles outside of town. My uncle and grandfather had a cabinet shop, and they slowly let me do a little bit. There was also a local blacksmith, and I did a project with him at his shop. That was where I learned about welding and using a lathe. I didn't do either one of those then, but I watched and got fascinated. Also, my scoutmaster maintained all of the trucks and heavy equipment for a large grape grower. He was just down the street, and I loved to go and watch him working on motors, fabricating whatever needed to be made to get things working. It was a neat time because you could see things being made from scraps or odds and ends. If you couldn't buy a replacement part, you often had to make one.

How did you discover your talent for sculpture and what was your first sculpture?

During my junior year at San Jose I got a job in the three-dimensional design shop that I had for about four years, all the way through graduate school. There was a table saw, bandsaws, sanders, grinders, and various hand tools in the shop. I was then still a commercial art major, but every once in a while on a slow night I'd start picking up scraps and making something. I made a chair literally of junk from the throwaway box, and it was so enjoyable that it piqued my interest in making things with my hands. In a way, that chair was my first sculpture, and I entered it into the annual student show. When it was accepted I got so excited. I had thought with my undergraduate degree I was doing something I enjoyed—drawing and painting—that was going to give me the skills to get a job. When I switched to sculpture, I realized, "I passionately want to do this," and I had no clue how I was going to make a living.

What was it like to study with Fletcher Benton and Peter Voulkos, and what did you gain from that experience?

Fletcher started teaching at San Jose when I was just finishing my requirements in sculpture. I had already decided that I wanted to work in kinetics, so it was a perfectly natural thing for me to want to work with him. We hit it off pretty well, and he was intrigued by the kind of skills I had, which were different than those he had. At that time he was running his studio as well as teaching, and he had three graduate students doing part-time work there. After a year or two I started working with them, doing some of the kinetic mechanisms for Fletcher's sculptures.

I think the biggest thing I gained from him was that he was extremely encouraging and supportive of me. He served as a role model in that he did something very few artists are able to do: not only make work, but handle dealers, and individuals, and somehow sell work in galleries—it wasn't easy to get into a gallery. I've actually maintained a strong friendship with Fletcher. We see each other quite often and I still ask him for advice.

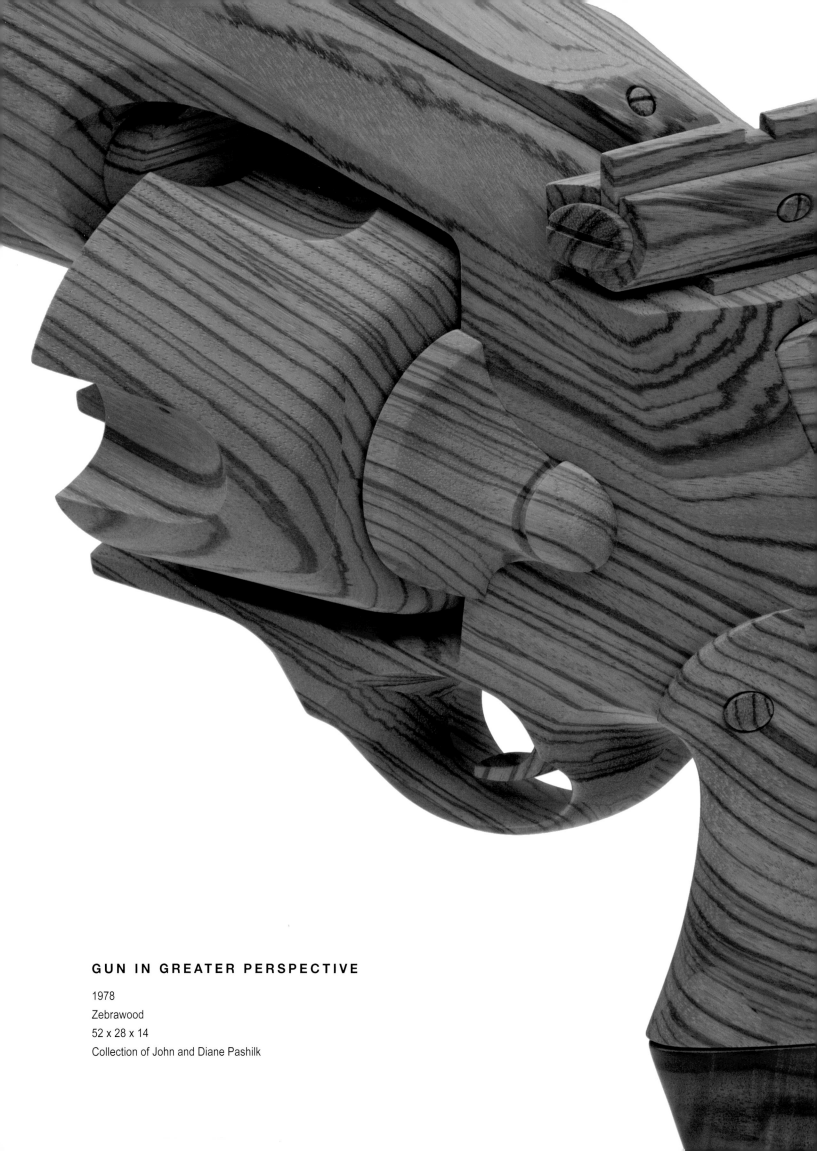

GUN IN GREATER PERSPECTIVE

1978
Zebrawood
52 x 28 x 14
Collection of John and Diane Pashilk

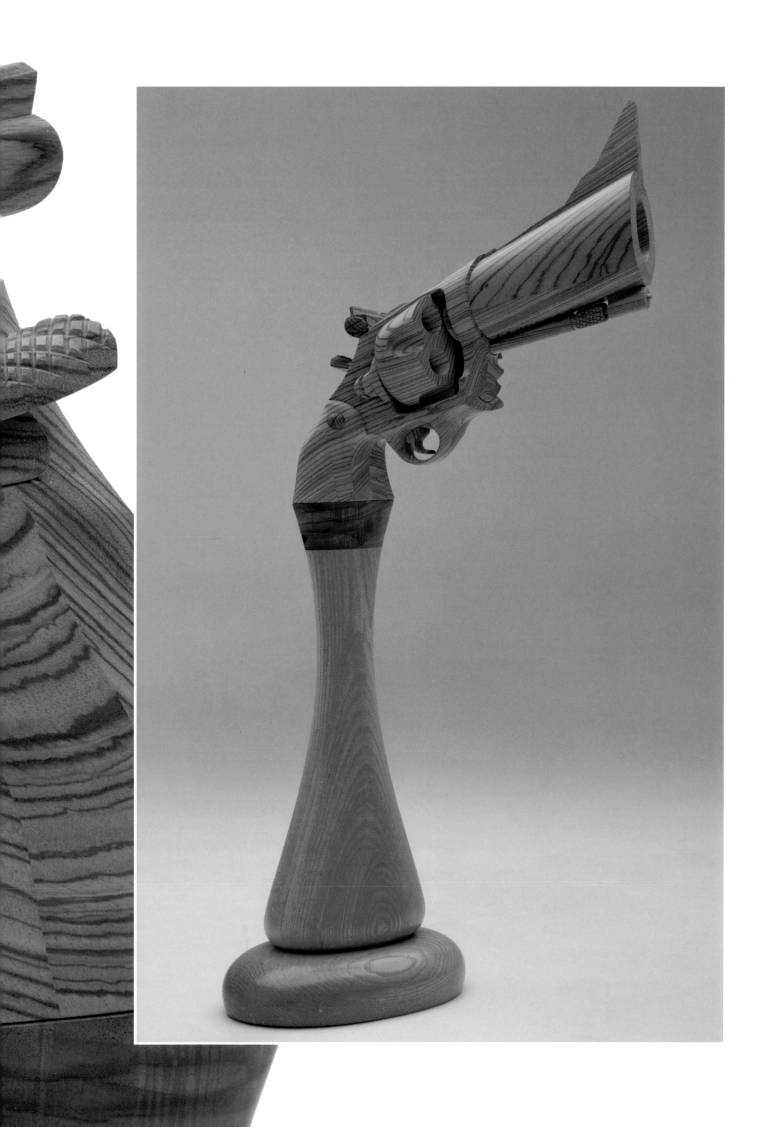

With Pete Voulkos the situation was quite different. I didn't get a chance to work with him as much as I would have liked. I was living in Los Gatos at the time and was in the graduate program at UC Berkeley. I was the only MFA student in sculpture. I think Pete was actually excited about my work when I presented it to the art faculty at Berkeley, because all of them voted, and they chose three painters and me as the sculptor. I felt comfortable with him because of our interaction on that day, so I visited him in his studio a number of times. Like Fletcher, he had a big operation— a huge warehouse where he was doing some ceramics, but mostly he was casting his large bronze sculptures. Seeing both artists' productions and their real sense of commitment to the work…everything about that was very inviting to me.

So, was it more their process rather than the materials that made an impact on you?

Yeah. I've never worked in clay like Pete. I took one class and enjoyed it, but I knew it wasn't a material I would stay with. I've always gravitated toward working with wood, aluminum, and some steel. I knew how to weld a little bit, and some methods of fabricating, and what I do has sort of been an outgrowth from when I was a teenager. I guess I have an intuitive sense of how things can go together. I pick up things by looking. It just seems pretty straightforward.

Are there any other artists or artistic movements that have influenced you?

I think the greatest influence was seeing *American Sculpture of the Sixties* at the Los Angeles County Museum of Art in 1967. That show had a huge impact on me. One artist I remember was Stephan von Huene. I only saw a few pieces of his at that show, and later a couple at the Museum of Modern Art, but he was doing beautifully crafted wooden pieces that were somewhat funny. They weren't comical, but they would move by the mechanism of a player piano. The sculptures made these twitchy, funny movements—almost

puppetlike—and nonmusical sounds that were amusing. The amusement, his unique high craft, especially using wood…everything in the exhibition was of such quality it made me think I'd love to do this.

What else did you see in the show and how did it change your thinking? Was it just that one artist?

He certainly had a big impact, but there was also Mark di Suvero. He had a gigantic sculpture made out of old, rough wood and discarded steel elements. It was this large mobilelike thing you could hang on and move with two people in the corners. And then there was H.C. Westermann. He did a piece in wood called *Antimobile*. It was a tall, stationary column with a steering wheel that wasn't round. The whole thing was just beautifully crafted and humorous and confusing at the same time.

Some artists were doing high-tech things, like Fletcher. Len Lye did a fantastic piece called *Flip and Two Twisters*. There was a long, thin stainless-steel band, and an electric motor that rotated it. When that piece of stainless flipped, it would make some sound. Then there were two outrigger pieces that would spin at different speeds and make sounds that would change in pitch—they were very visual.

The show was exciting; it was confusing. The scale of the pieces and just the huge swing of directions made a big impression. You know, you're making things in your mind that you are going to make with your hands, and that huge diversity is very powerful.

In 1975 you made *Soapbox Racer*, an "art car." How did that come about?

That was Fletcher Benton's idea. He was connected with a committee at the San Francisco Museum of Modern Art that was exploring some ideas, and he said, "How about an artist race?" I know Fletcher probably advanced my name, because I was little known. Immediately I got sucked into it. It was a pretty large project for a one-day event.

That was my big year of laminating, where I was doing three bent-laminated pieces. There was some serious carving that wasn't laminated, but also developing forms that I was very interested in exploring, and an organic theme that has resonated with more of my work since. If I do any teaching now it's almost always an invitation to talk about my laminating techniques, because I do things that are off the norm in combining laminating with other elements.

You spent some time in Australia in 1978. Can you talk a bit about that?

I competed for and won a fellowship called Craftsman in Industry, which was offered by the Crafts Council of Australia. So, we moved there and it was quite different being in the setting of a furniture factory rather than at a school. We were in Brisbane for three months and Perth-Fremantle for two months. Both working locations were in wood furniture factories. I worked on a sculpture in each place and gave demonstrations and talks to interested groups, including college programs. The remaining time was spent in two-week stays at each major city in Australia, where I led workshops and lectured at various colleges specializing in art and crafts. I think the craftsmen there were interested in what I was doing with bent lamination and wondered about the possibilities of applying my techniques to their own work. I got to meet some fine Australian craftsmen and had a chance to have my work seen by a wider audience. It was a validation for me. I got a great reaction to the two pieces I made there, and one was purchased by a museum in Tasmania. It was a terrific experience in every way.

I've recently finished another sculptural chair piece, the twelfth to date. I've been working on this series for around ten years. The new chair's got many parts that are wood, but also some steel, some aluminum, some paint, and some chrome. The exercise is trying to do bent lamination with solid-wood carved forms and metal and make a cohesive whole. I just love that.

How did movement become something that you wanted to incorporate into so many of your sculptures?

When I had to write a project statement for my MA at San Jose, I decided to do kinetic sculpture and looked at the major books as to what was being done. Of course, Calder and George Rickey were the two working with wind as their primary driver of moving parts. And Stephan von Heune was doing very deliberate things through the player piano mechanisms. Then there were others, like Takis, who was using electromagnets. And Paul Bury was using permanent magnets. I started to use permanent magnets, so there was an element of mystery of how something moved. So the movement, to me, added just another wonderful element. You are looking at a sculpture that has form, but if the sculpture could change or could do something that would be a surprise or another element that you can react to… that was a very interesting and intriguing idea.

Gun violence seems to be a central theme in your work and it's often combined with other themes of childhood innocence. Why that duality?

In 1976 I wanted to do a group of pieces, and I decided on the use of a handgun image. As a young child, I borrowed a BB gun to play with and hit a bird. Looking at it much later, I didn't know at that time what my action might do, and it had a profound effect. Then I was held up in my dad's grocery store at closing time when I was a teenager. After, I was faced with the idea that every night my dad would close the store exactly like I was doing that particular night, so I was scared to death for him. That was my first real encounter with a gun in terms of a potentially violent act. Then in college, the Vietnam War was heating up, and I realized that warfare is not a solution. I resisted the draft and eventually got my conscientious objector status. Those experiences laid the groundwork for the gun series.

I think the best piece in that group is the *Trainer Tricycle*. It's the combination of a child's tricycle with a gun that fits into the exact contour of the frame, going from the rear wheel crossbar up through the handlebars. I like it because, as kids, we would play cowboys and Indians, and everyone wanted to have a cap gun. That was just a way of playing; of course, we were playing with guns. I think one of the problems of our society is that we participate in some seemingly innocent behavior that can feed into violent behavior later on. So, I thought that the tricycle and the gun—bringing those two together—that to me was a good piece. A later work, *Gun in Curved Perspective*, is literally the rendering of that robber's gun being pointed at my head—how large the barrel seemed to get.

Can you talk about the piece *How the West was Won, How the West was Lost?* Do you think its themes are as relevant today as when you started it in 1977?

Seems like it. With the Gulf oil spill and the gun problems we have in the world… I honestly think the violence is worse now because it's more sophisticated. And of course, we are all still just as addicted to oil. It will literary take, I think, the government to say, "In five years we will no longer produce an internal combustion car, we will offer new cars that will be electric or hybrid." The public would be angry. *I* would be angry, only because I've grown up with these things and I love the way they sound, I love the way they work. But we need to change and it's going to take somebody that's going to say, "We need to change NOW."

So, because we're still dealing with the same problems, you've been able to sustain your interest in working on this piece?

I have. The only thing that's sort of maddening is getting it to a point where it's going to work off of a computer. Anything mechanical has been either fun or challenging. It often is too slow in the making,

but that's part of the deal. You know when you decide to do something like this it's long term. The fact that it's relevant certainly makes it worth wanting to finish.

What are your favorite projects to date and why?

Honestly, often the one you're working on becomes your favorite. *Ride* would have to be one of my favorites. It will simulate trying to fly, and hopefully will hop. If that does everything it should, that's going to be an important piece from my standpoint. It's a technical challenge—lots of technical metalworking, and actually some engineering. I have no training in engineering, but I enjoy trying to figure out how this could do that, and how it might work. Different pieces have been significant for either a breakthrough in my learning or seeing something new.

What would you like to do in the future? Is there a piece that you'd like to make?

I want to make another hot rod. It would be a design exercise using some old elements from racing and some new elements that I have in mind. Design, and the way I use it, is not a dirty word. I think it's sad that in the way we speak about contemporary sculpture, you do not mention craft or design—those are lower-level endeavors. And I think that's crap. Many sculptors, art writers, and art curators are having an art dialogue in elitists' terms, which has really no value toward communicating or trying to connect with the public. What's the point of making your work distant from the people who want to understand it?

You want people to connect, so what would you like them to take away from an encounter with your work?

I literally hope I can get people excited and enthusiastic. For adults, I would like them to look at a piece and enjoy trying to figure it out: "OK, what does this do?" and, "Oh, I see. This does *that*." I also would love to feel that some of my work could get kids excited about making, to

help them understand both the joy of it and how you can make anything with a few simple tools.

Any recommendations, advice, or words of encouragement for aspiring artists?

What I used to tell my students is that I learned art was important to me. It just felt very real, very satisfying, very challenging, and it's an activity you can sink your teeth into. What I believe in the strongest is that you've got to somehow figure out what you're passionate about. The one thing I hope I can leave behind is to reach a few people, to encourage them to be passionate about the idea of seeking a creative path.

I visited with Sam Maloof about a year before he passed away. He was ninety-three, and he was still working pretty damn well, so he's one of my role models. I could start a whole new career tomorrow doing something I love if I had the time. The sky's the limit. It's like music—you think that everything's been done, but then you hear all these whole new directions, reinterpretations, of music. It's in reinterpreting that you're able to explore, "What do I think?" The thought isn't then responded to with an answer that's verbal. The sculptor's answer is visual, and no matter what, whenever you make something, the process is relatively slow, so you have time to think, "Do I really like this? Is this a solution?" Well, it's a solution for now, and it may inspire the next project. Often when it does, it's magical.

Karin C. Nelson
Karin C. Nelson is an independent curator and writer.

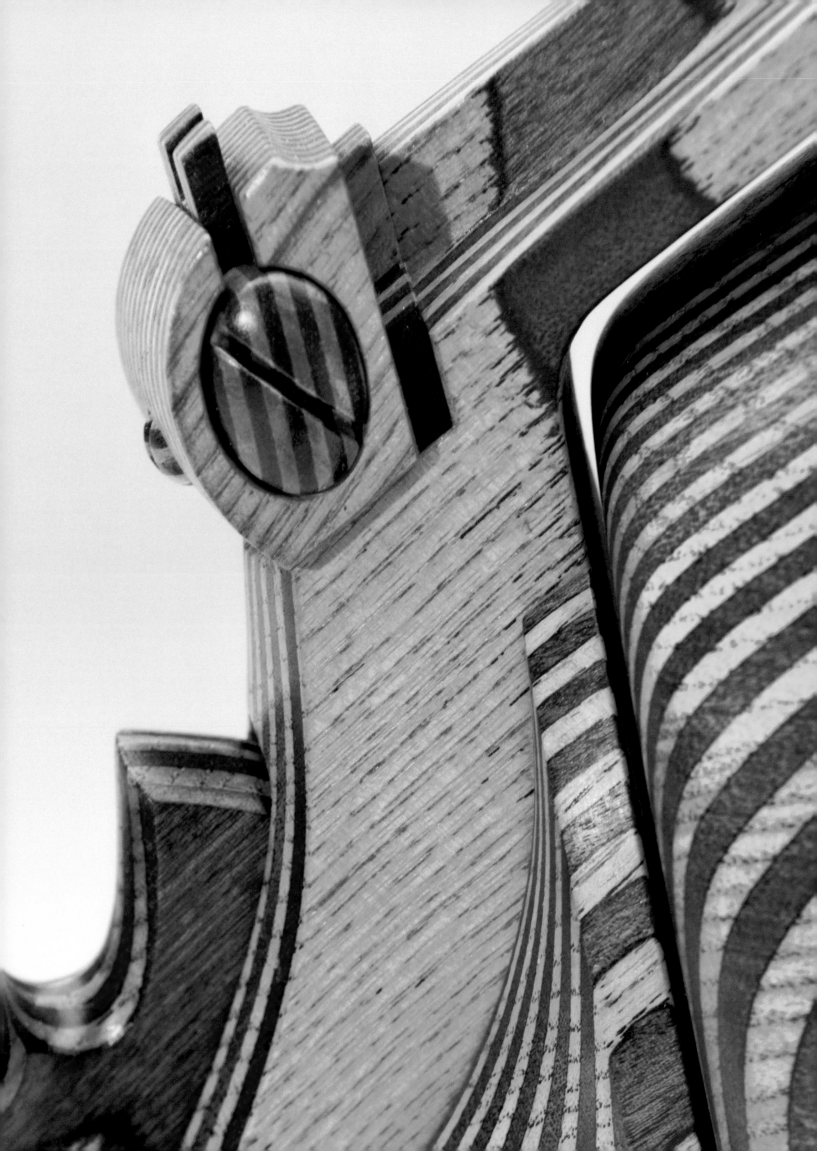

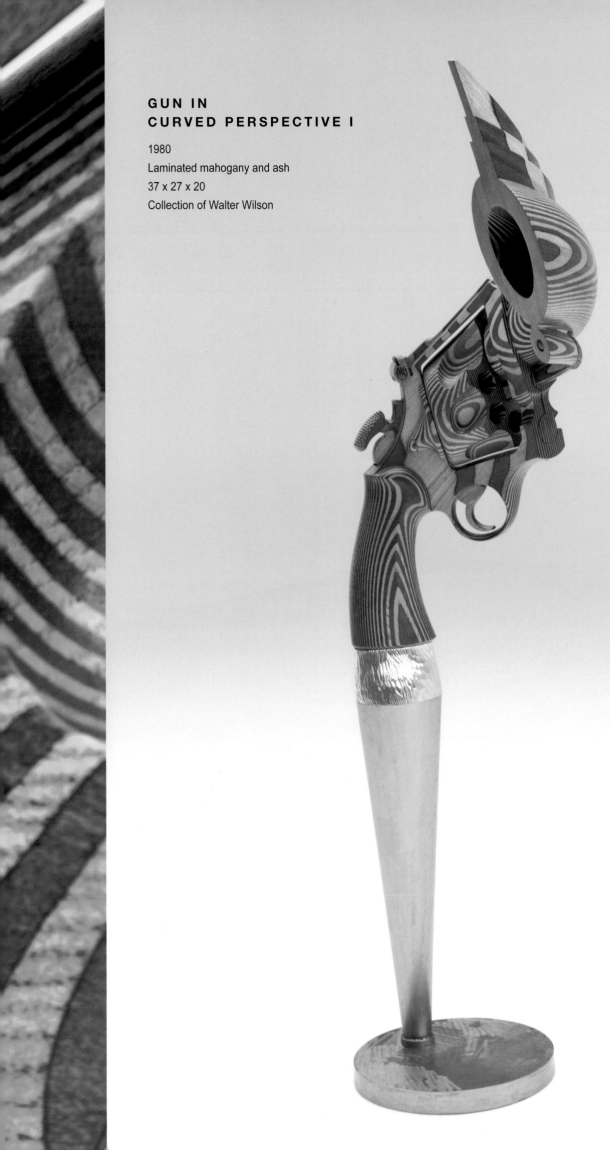

**GUN IN
CURVED PERSPECTIVE I**

1980
Laminated mahogany and ash
37 x 27 x 20
Collection of Walter Wilson

GAYLE

1985
Hard maple, oil paint, lacquer
67 x 24 x 22
Sam and Alfreda Maloof Foundation for
Arts and Crafts
Photo: R. J. Muna

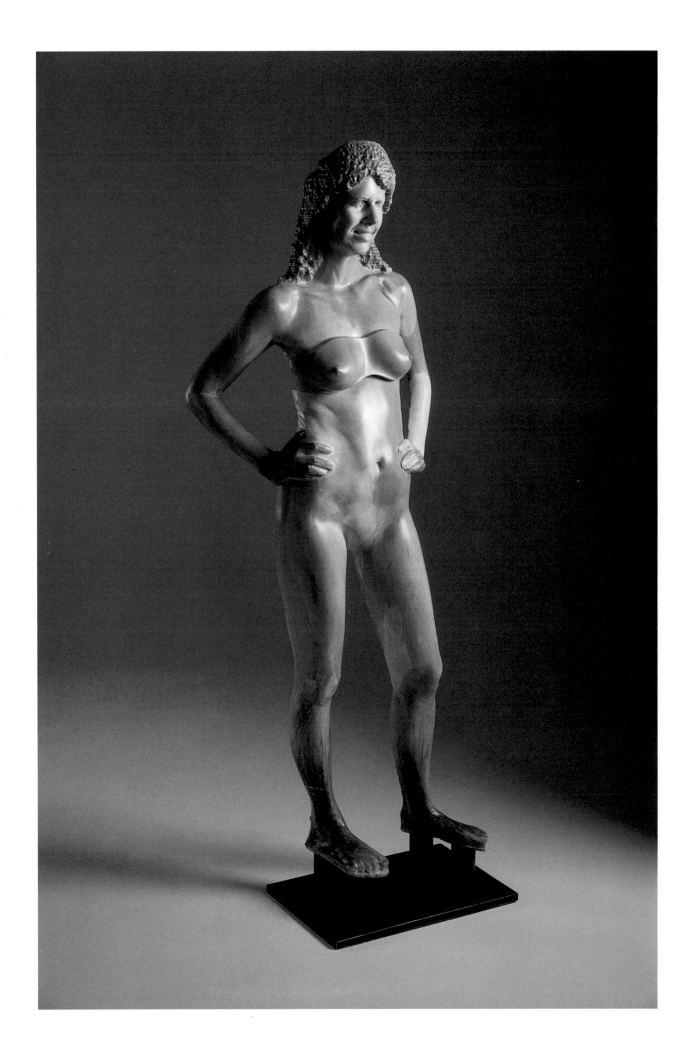

TORSO #3: ANNE

1986
Hard maple, oil paint, lacquer
28 x 16 x 10

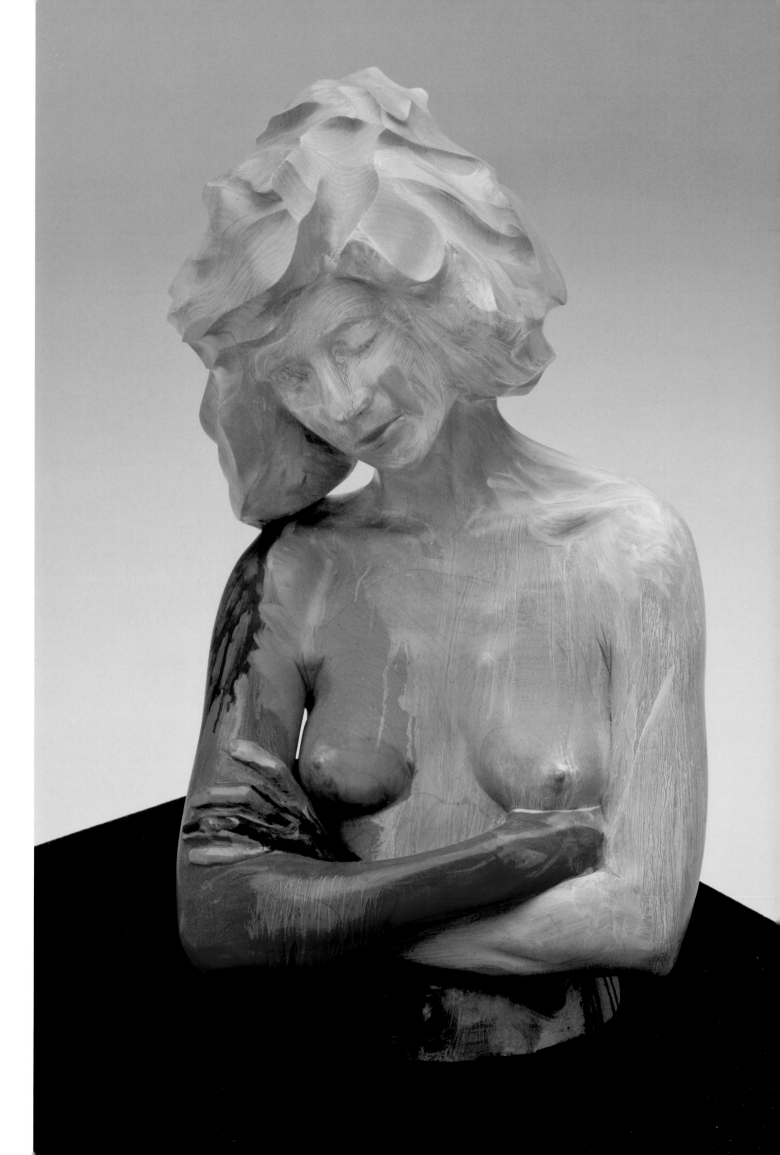

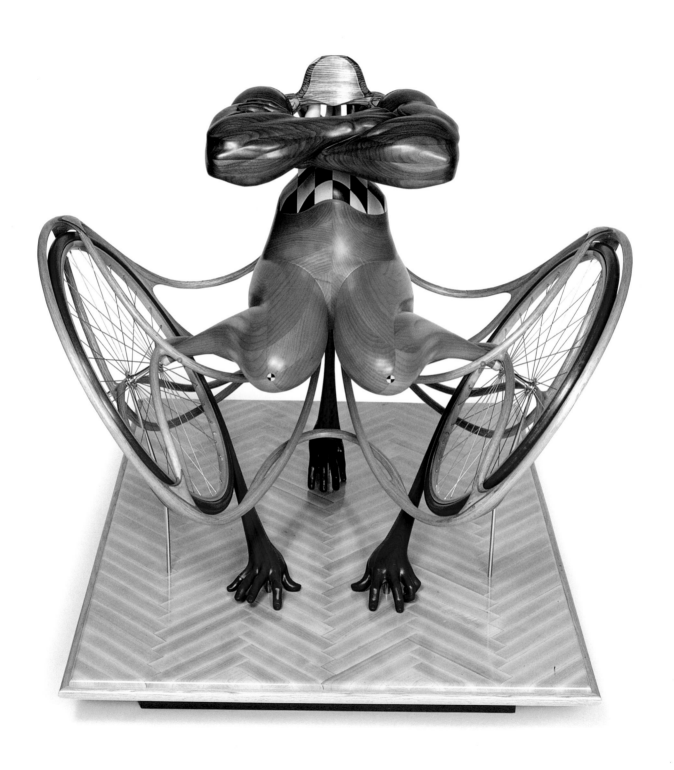

OVERARMED WHEELCHAIR

1989
Laminated hardwoods, bicycle wheels
56 x 48 x 52
Collection of Karl E. and Lucia M. Ryerson
Photo: R. J. Muna

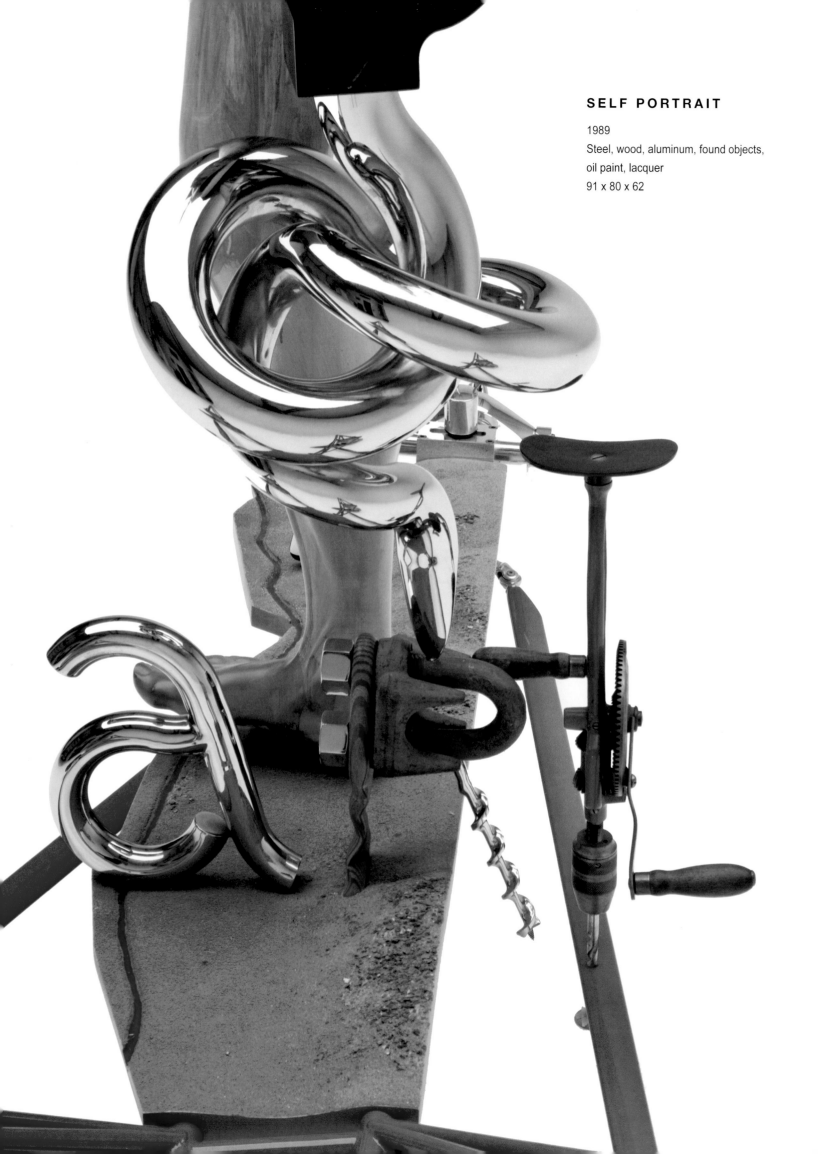

SELF PORTRAIT

1989
Steel, wood, aluminum, found objects,
oil paint, lacquer
91 x 80 x 62

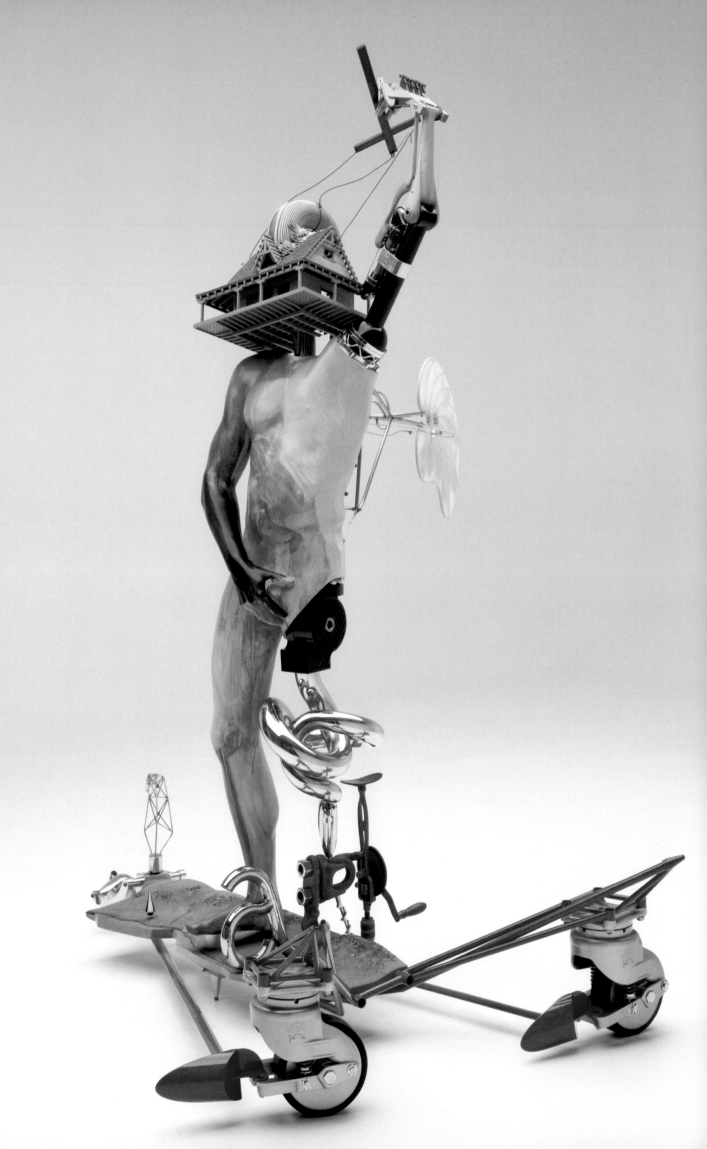

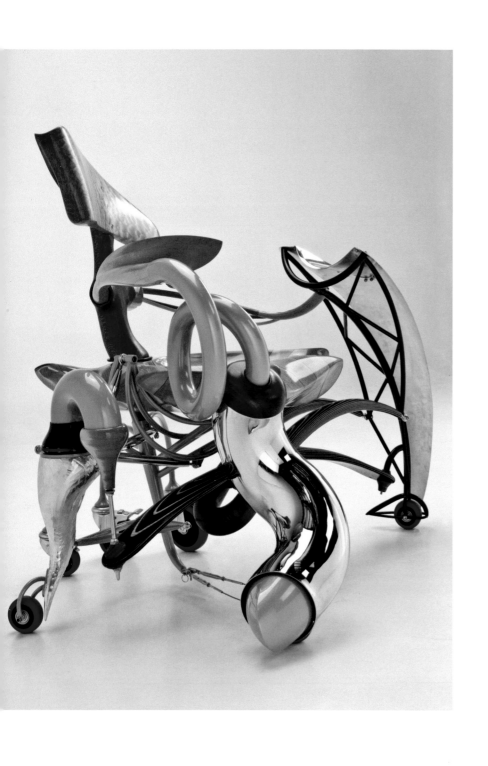

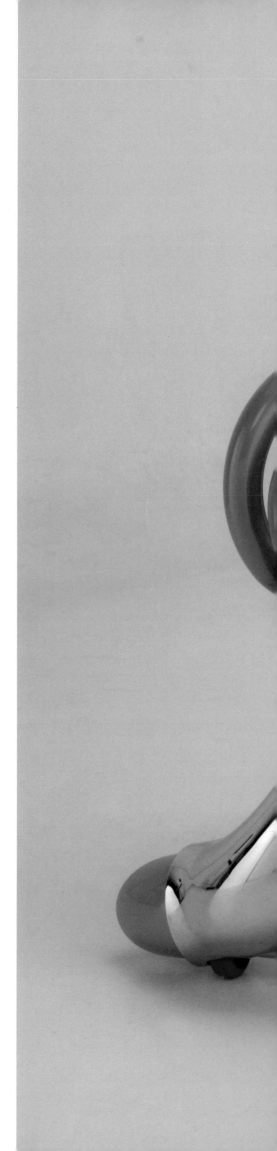

PEACHES

2004
Wood, steel, aluminum, wheels, found objects
42 x 46 x 36

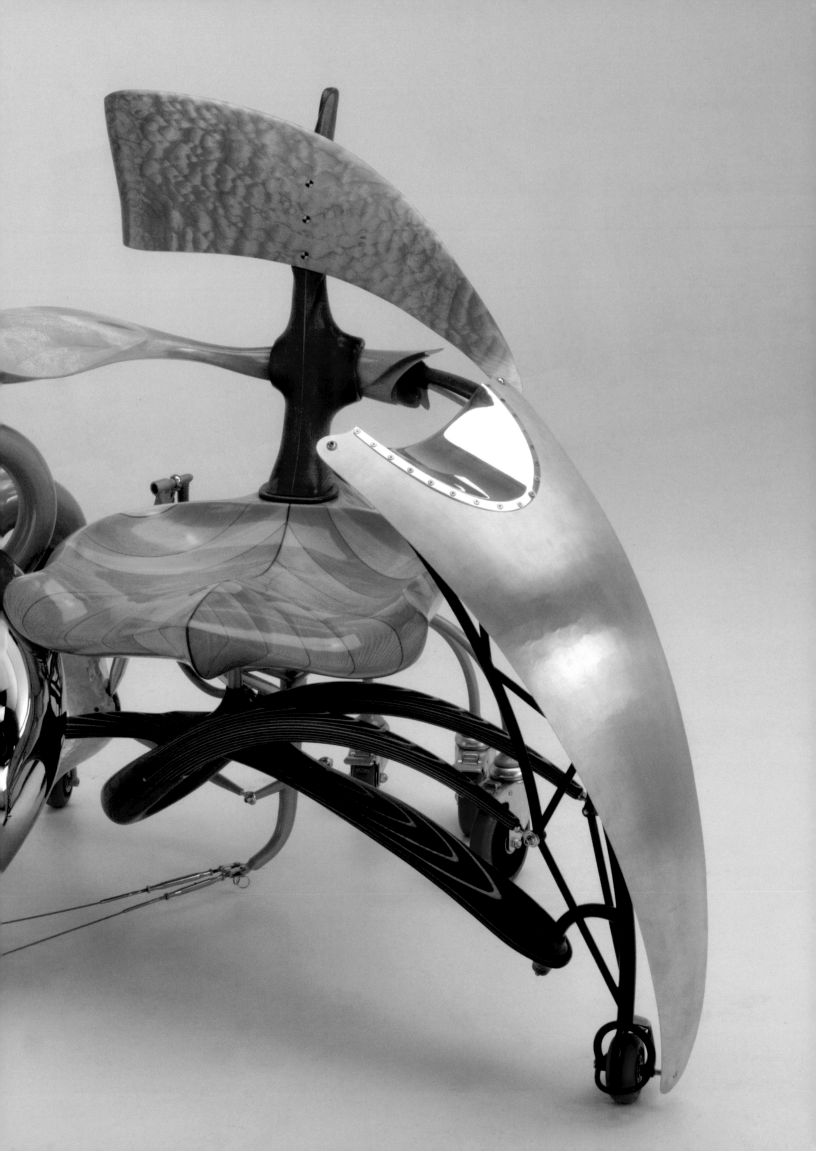

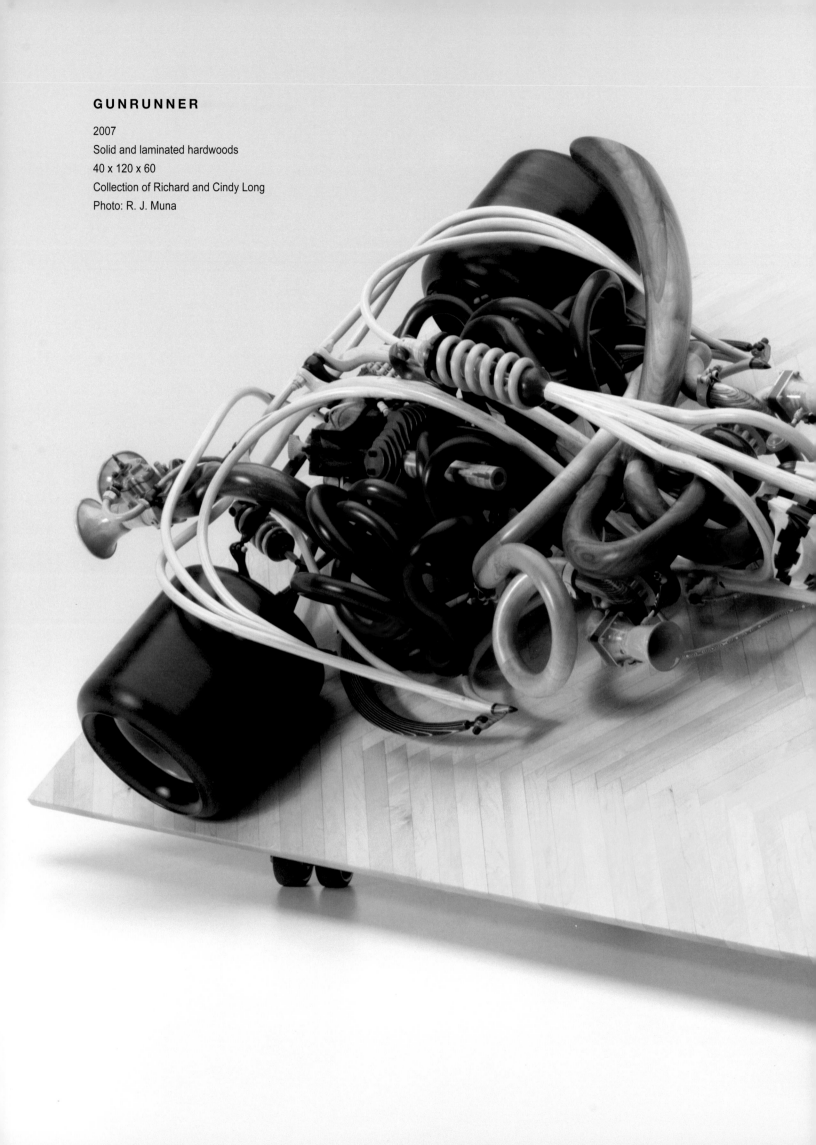

GUNRUNNER

2007
Solid and laminated hardwoods
40 x 120 x 60
Collection of Richard and Cindy Long
Photo: R. J. Muna

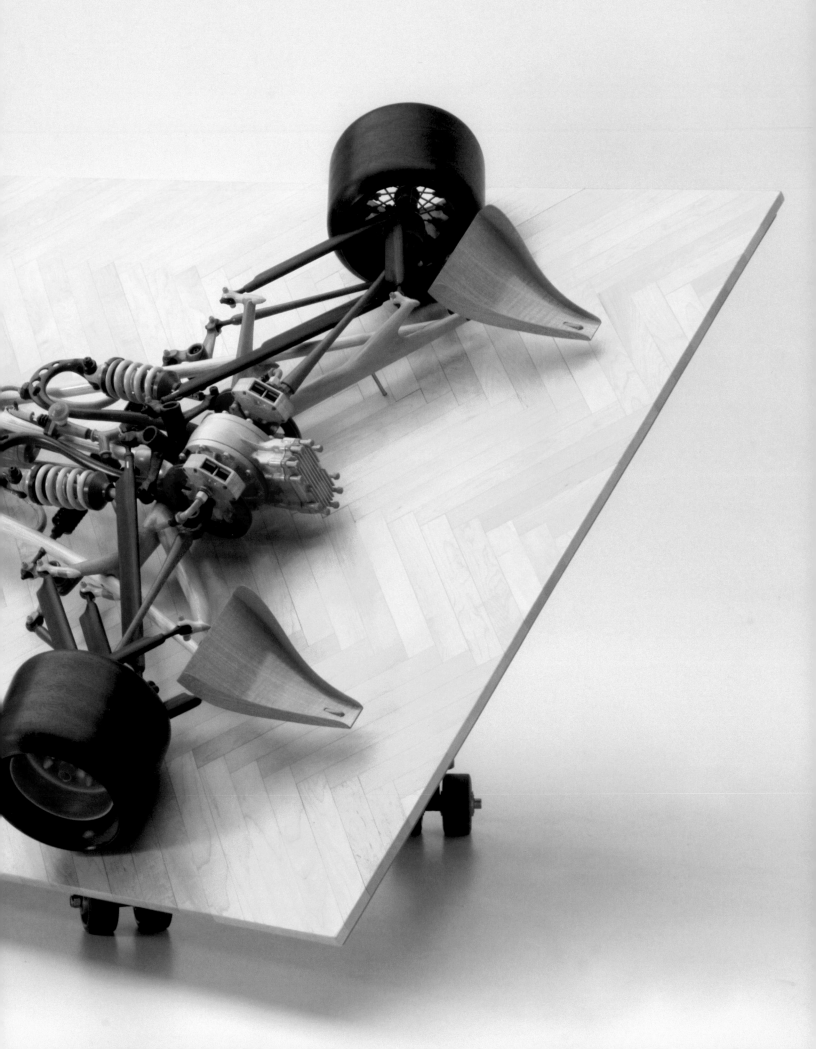

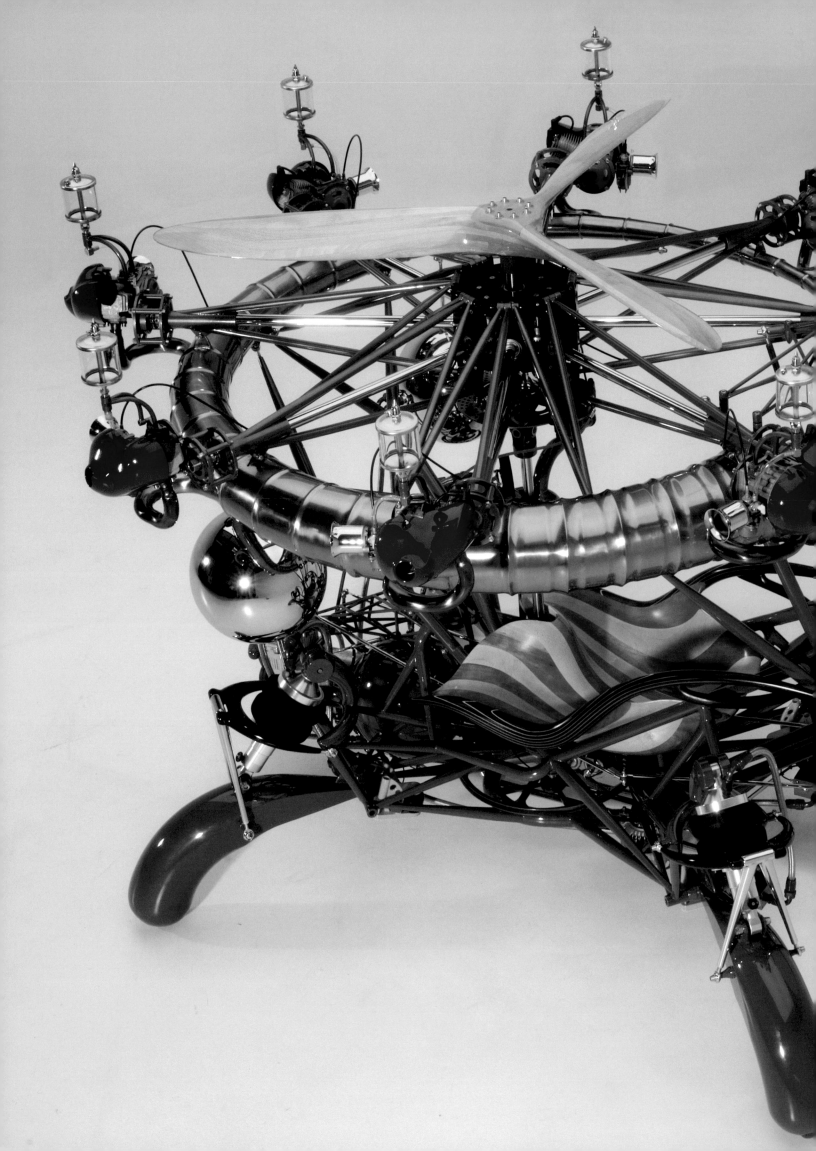

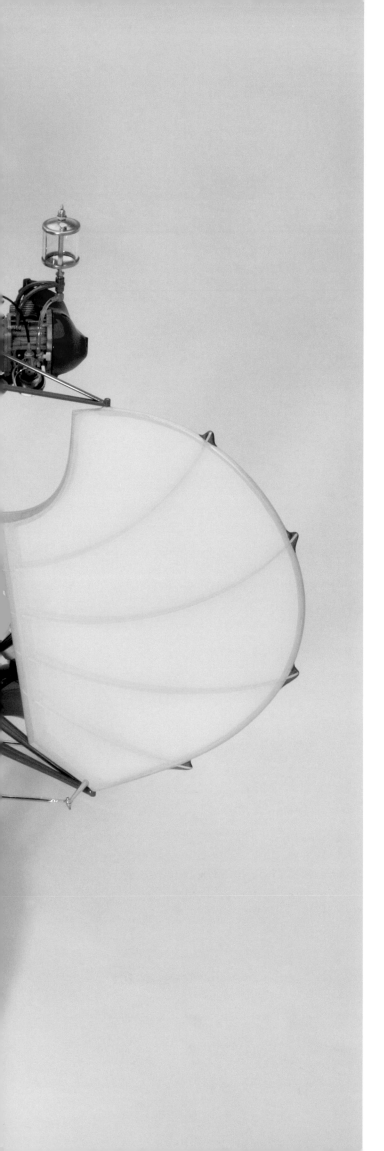

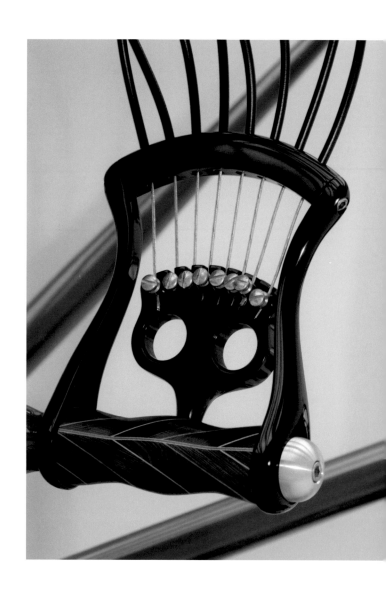

RIDE

2008
Steel, aluminum, wood, gas engines, pneumatic air system
67 x 77 x 82

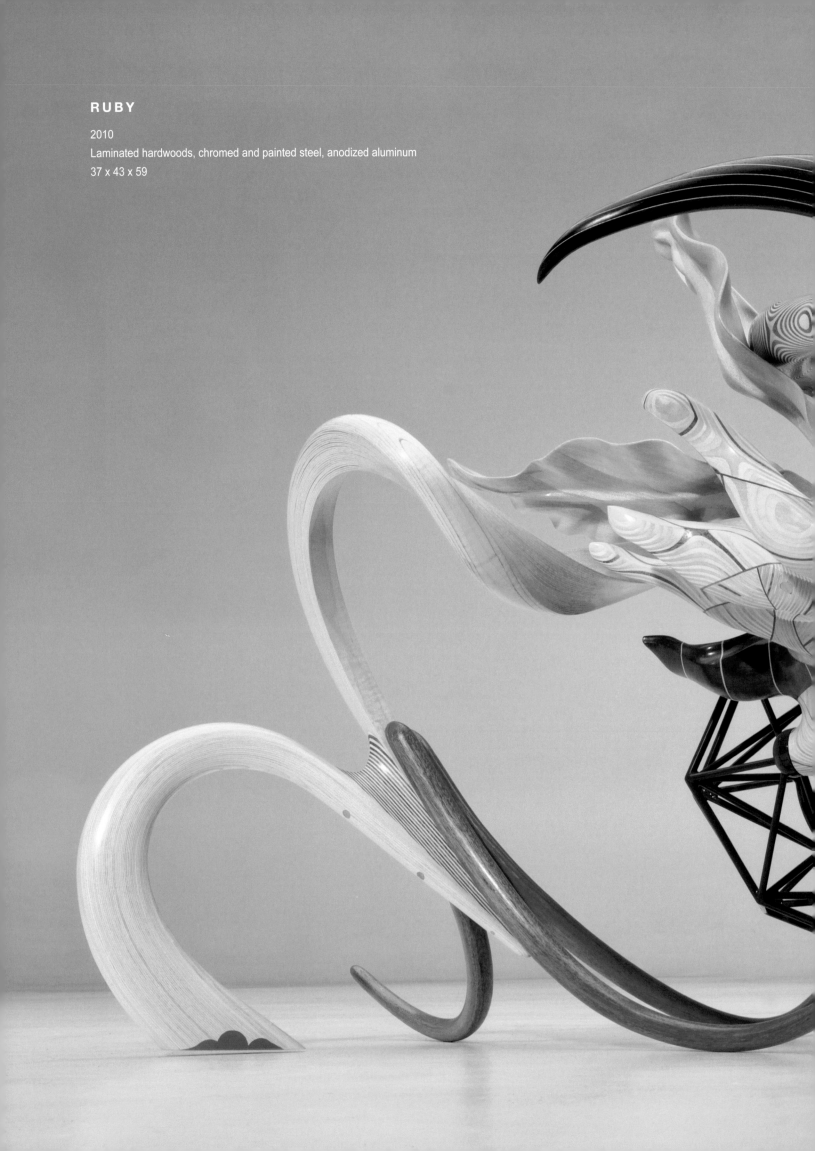

RUBY

2010
Laminated hardwoods, chromed and painted steel, anodized aluminum
37 x 43 x 59

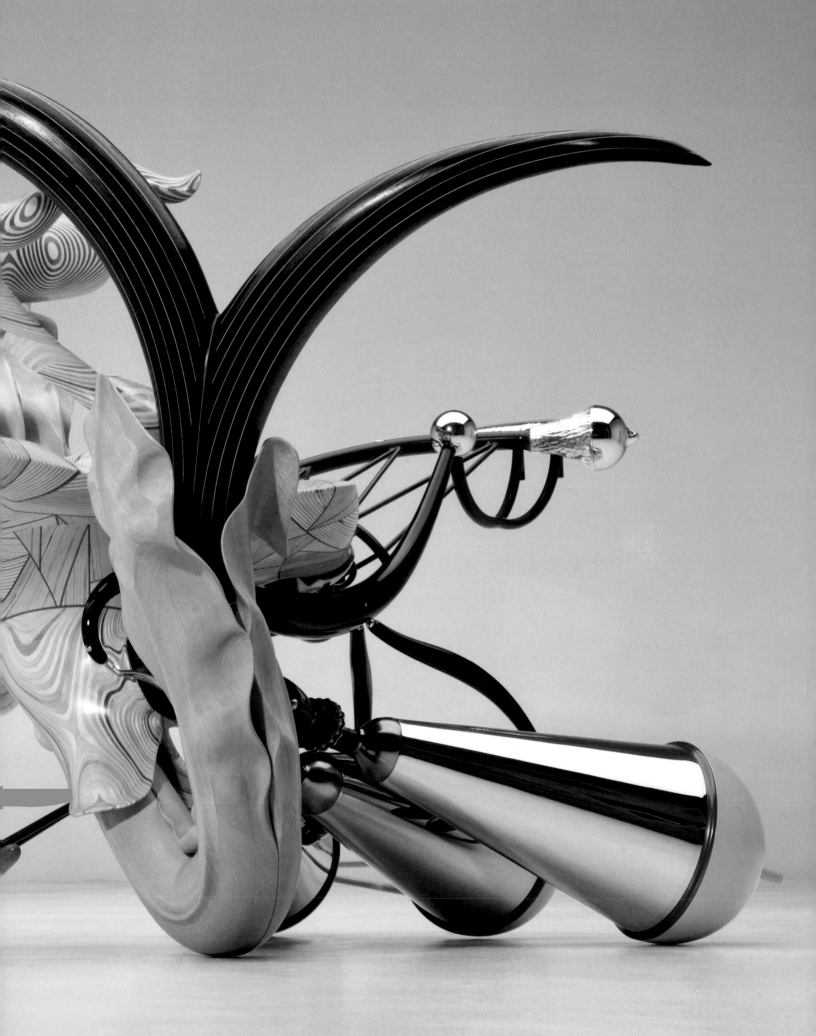

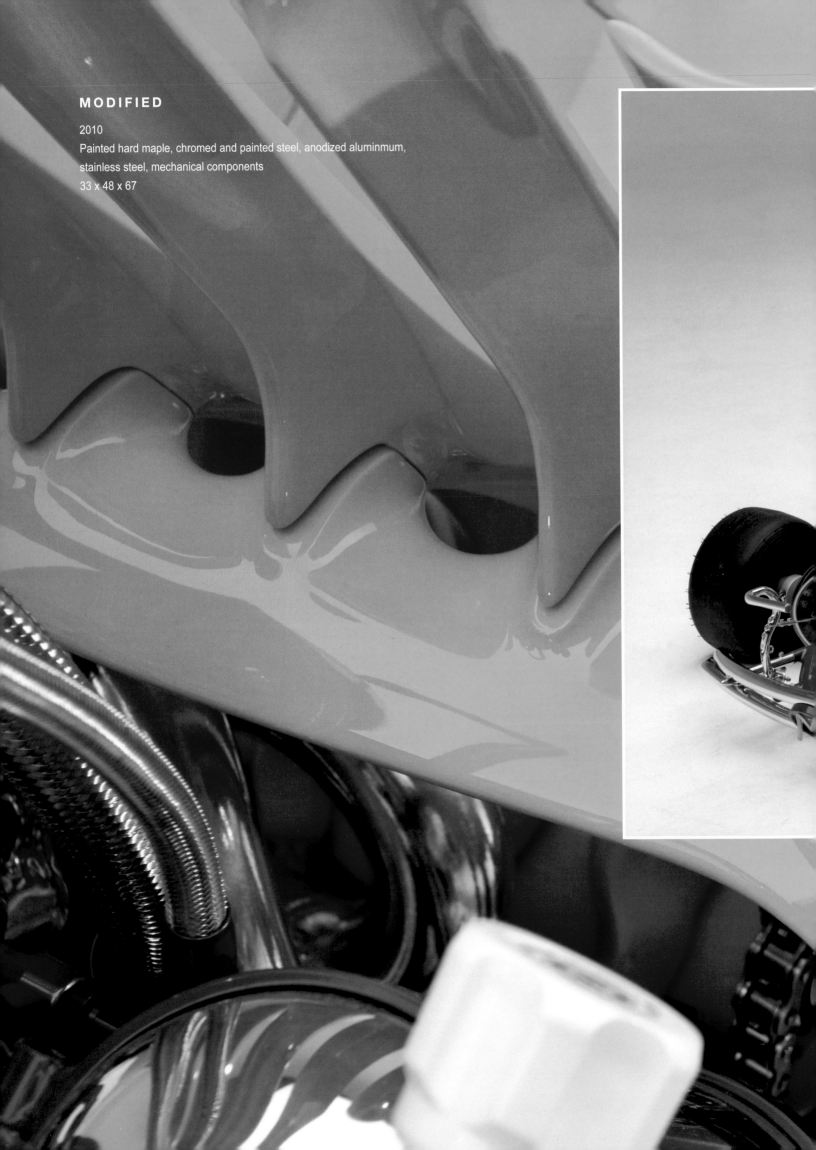

MODIFIED

2010
Painted hard maple, chromed and painted steel, anodized aluminmum,
stainless steel, mechanical components
33 x 48 x 67

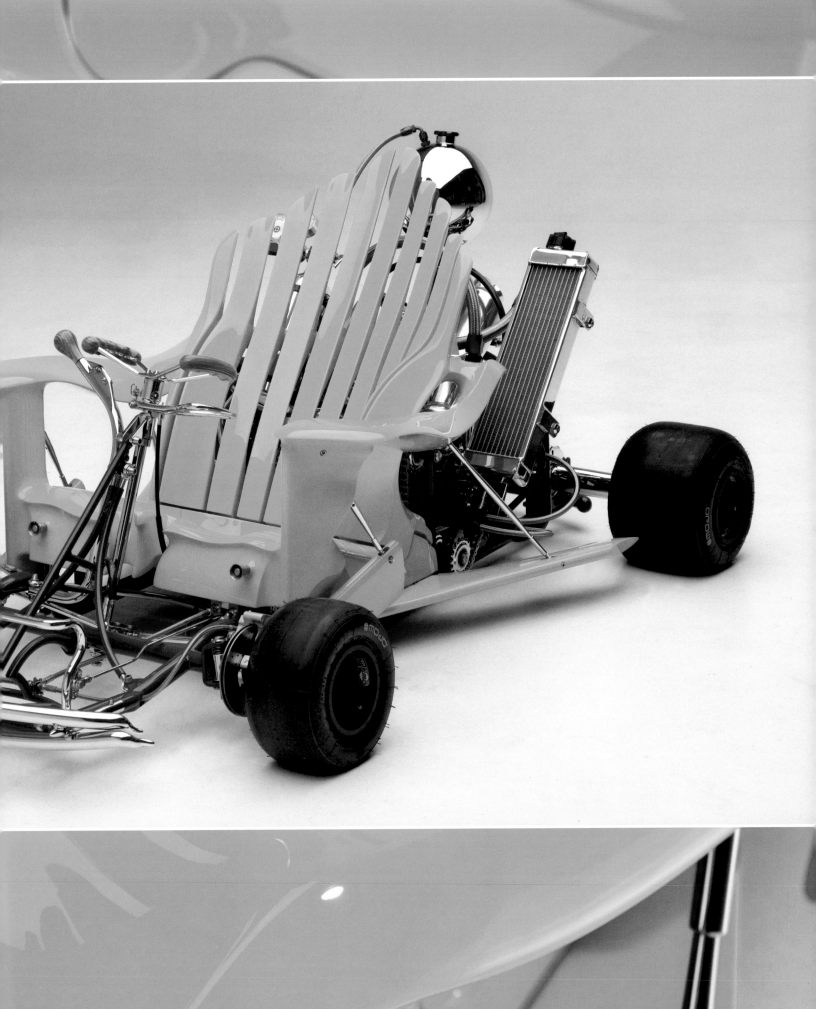

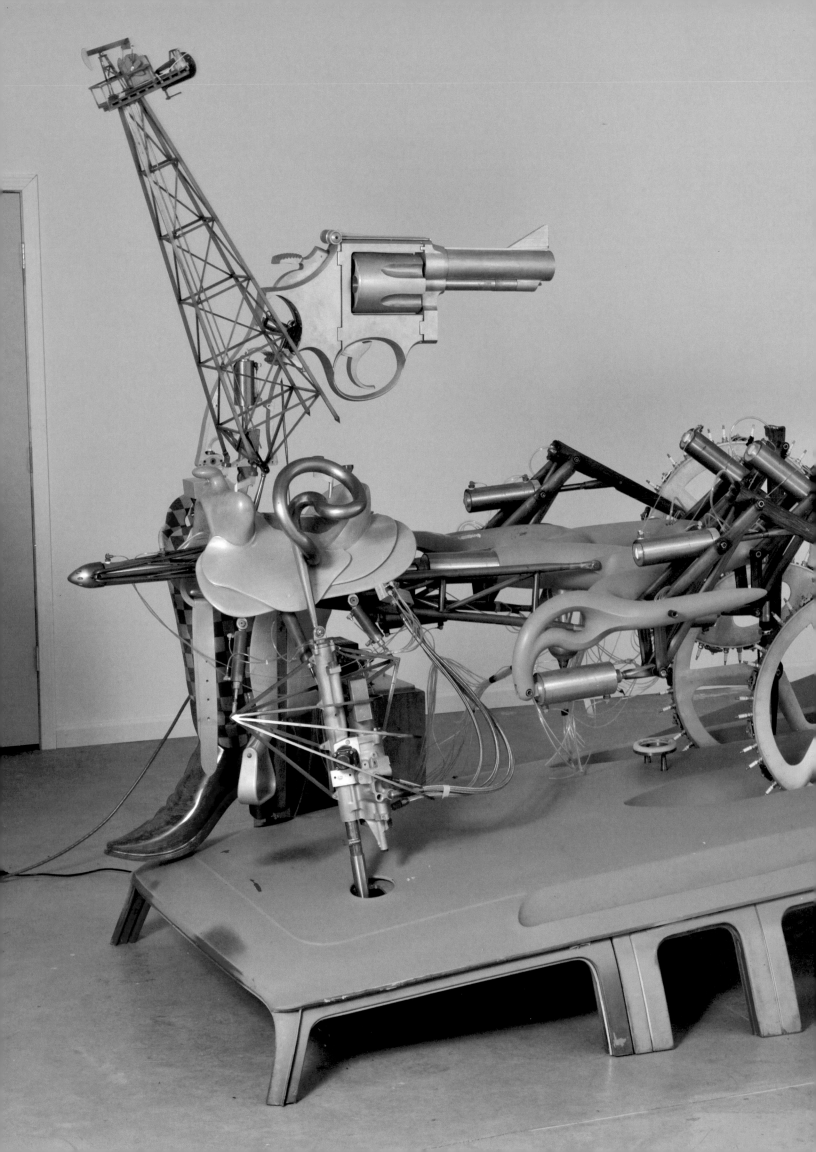

**HOW THE WEST WAS WON,
HOW THE WEST WAS LOST**

1977–2011
Steel, hardwood, aluminum, pneumatic systems
92 x 120 x 70

Michael Cooper
Selected Biography

EDUCATION

MFA, Sculpture, University of California, Berkeley, California, 1969
MA, Sculpture, San Jose State College, San Jose, California, 1968
BA, Commercial Art, San Jose State College, 1966

PROFESSIONAL BACKGROUND

2009	Wornick Visiting Professor of Wood Arts, California College of the Arts, San Francisco, California
2004	Instructor, California College of the Arts, San Francisco
1977–2004	Instructor, De Anza College, Cupertino, California
1969–1977	Instructor, Foothill College, Los Altos Hills, California
1969	Instructor, University of California, Berkeley
1967–1968	Graphic Designer, Illustrator, Steven Jacobs Design Associates, Palo Alto, California
1967	Graphic Designer, Graphic Center West, Sacramento, California
1966–1968	Graduate Assistant and student, San Jose State College
1966–1967	Graphic Designer, J.L. Brandt and Associates, Los Altos, California

GRANTS AND AWARDS

2010	Best in Show, *Artistry in Wood*, Sonoma County Museum, Santa Rosa, California
1998	First Place Professional, *American Woodworker Magazine*, Woodworker Award, for *Gunshy*, December
1993	President's Award for Outstanding Service, De Anza College
1992	Discovery Award, Silver, *Art of California* Magazine
1990	Award of Excellence, Sonoma County Woodworkers' Association
1979–1980	Fellow in Sculpture, American Academy in Rome, Italy
1979	Fellowship, Crafts Council of Australia, Craftsman in Industry
1978	Craftsmen's Fellowship Grant, National Endowment for the Arts
1977	SECA Award, Society for the Encouragement of Contemporary Art, San Francisco Museum of Modern Art
1974	Professional Development Grant, Foothill College
1972	Foothill College Innovations Committee Grant
1969	Eisner Prize for Sculpture, University of California, Berkeley
1967–1968	Scholarship, San Jose State College Associated Student Body
1966	Graduate Research Grant, San Jose State College
1966	Graduated Dean's Scholar, San Jose State College

SOLO EXHIBITIONS

2011–2012	*Michael Cooper: A Sculptural Odyssey, 1968 – 2011* Museum of Craft and Design, San Francisco, California Fuller Craft Museum, Brockton, Massachusetts Bellevue Arts Museum, Bellevue, Washington
2010	*Return of the Lodi Madman*, Quicksilver Gallery, Forestville, California
2007	*Michael Cooper, Formerly the Lodi Madman*, Quicksilver Gallery
1993	*Recent Work*, Union Gallery, San Jose State University, San Jose, California
1982	*Michael Cooper*, The Art Gallery of Western Australia, Perth
1978	*Michael Jean Cooper*, Redding Museum of Art and History, Redding, California and Central Oregon Community College, Bend, Oregon *Gun Series*, Union Gallery, San Jose State University
1977	*SECA Award Exhibition*, San Francisco Museum of Modern Art, San Francisco, California
1976	*Michael Jean Cooper*, Boehm Gallery, Palomar College, San Marcos, California
1969	*Cooper Super Thing*, Oregon College of Education, Monmouth, Oregon *Kinetics*, Esther Robles Gallery, Los Angeles, California *Kinetic Sculpture*, Arleigh Gallery, San Francisco, California
1968	*Smoothies and Bumpies in Kinetic Sculpture*, Master Exhibition, San Jose State College, San Jose, California

GROUP EXHIBITIONS

2010 *Mad Science – Experiments in Kinetic and Robotic Art*, Sonoma County
 Museum, Santa Rosa, California

 San Francisco 20th Century Modernism Show, Fort Mason, San Francisco,
 California

 Artistry in Wood, Sonoma County Museum

 Western Engine and Model Exhibition, Vallejo, California

2009–2010 *SOFA, Sculpture, Objects & Functional Art*, Chicago, Illinois and Palm Beach,
 Florida

2008 *Craft in America*:
 Cranbrook Art Museum, Bloomfield Hills, Michigan
 National Cowboy & Western Heritage Museum, Oklahoma City, Oklahoma
 Palm Springs Art Museum, Palm Springs, California

2007 *Craft in America*:
 Arkansas Arts Center, Little Rock, Arkansas
 Museum of Contemporary Craft, Portland, Oregon
 Mingei International Museum, San Diego, California

2006 *Fire-Good*, A Street Gallery, Santa Rosa, California

2005 *Sculpture Sonoma 2005*, Santa Rosa Junior College Art Gallery and Paradise
 Ridge Winery, Santa Rosa, California

 The Other Side, A Tradition of Alternatives, San Diego State University,
 San Diego, California

2004 *Faculty Show*, California College of the Arts, San Francisco

1999 *Far Out: Bay Area Design, 1967–1973*, San Francisco Museum of Modern Art,
 San Francisco, California

 American Woodworker Show, Ontario, California

1998 *Woodfest*, Southern Lumber Company, San Jose, California

1997 *SOFA, Sculpture, Objects & Functional Art*, Chicago, Illinois

 Forty-seventh Sacramento Autorama, Sacramento, California

 Forty-eighth Annual Grand National Roadster Show, Oakland, California

 Fresno Car Show, Fresno, California

 San Mateo Motorcycle Show, San Mateo, California

1996 *SOFA, Sculpture, Objects & Functional Art*, Chicago, Illinois

 De Anza Faculty Show, Euphrat Gallery, De Anza College, Cupertino, California

1995 *Wood Sculpture: Craft and Symbolism*, Ohio Craft Museum, Columbus, Ohio

 Wood Sculpture: Craft and Symbolism, 20 North Gallery, Toledo, Ohio

 SOFA, Sculpture, Objects & Functional Art, Chicago, Illinois

 SOFA, Sculpture, Objects & Functional Art, Miami, Florida

1994 *Celebration of Our History & Future*, Center for Art & Technology, Presidio,
 San Francisco, California

 De Anza Faculty Show, Euphrat Gallery, De Anza College, Cupertino, California

1993 *Motorcycles & Other Cycles*, Redding Museum of Art and History, Redding,
 California

 Group Show, William Zimmer Gallery, Mendocino, California

1992 *Three Artists: New Works*, San Francisco Museum of Modern Art Rental Gallery,
 San Francisco, California

1991 *De Anza Faculty Show*, Euphrat Gallery, De Anza College, Cupertino, California

 Group Show, William Zimmer Gallery, Mendocino, California

1988 *Portraits: An Extended Concept*, California Museum of Art, Santa Rosa,
 California

1987 *Faculty Art Show*, Haystack Mountain School of Crafts, Deer Isle, Maine

1986 *Fine Wood*, Euphrat Gallery, De Anza College, Cupertino, California

 Furniture in the Aluminum Vein, Kaiser Center Art Gallery, Oakland, California

 Fantasy on Wheels, Bellevue Arts Museum, Bellevue, Washington

1985 *Statements in Wood*, California State University, Northridge, California

 Three Woodworkers, The Haggin Museum, Stockton, California

 Works in Wood, Monterey Peninsula Museum of Art, Monterey, California

1984 *Bentwood Today*, Museum of Art, Rhode Island School of Design, Providence,
 Rhode Island

 Wood Renditions, Gallery at the Plaza, Los Angeles, California

1983 *Wood Invitational*, Gallery Fair, Mendocino, California

1982 *Faculty Art Show*, Euphrat Gallery, De Anza College, Cupertino, California

1980	*Annual Exhibition*, American Academy in Rome, Italy
1979	*Royal Show*, Melbourne, Australia
	Recent Work on Tour, Queensland, Australia:
	Queensland Museum
	College of Advanced Education
	Queensland State Art Gallery
	Institute of Modern Art
	Recent Work, Fremantle Art Gallery, Fremantle, Western Australia; Caulfield Art Center, Melbourne, Australia; Crafts Council of Australia Gallery, Sydney, Australia
1978	*Second Artists' Soapbox Derby*, San Francisco Museum of Modern Art, San Francisco, California
	Selections from the Second Artists' Soapbox Derby, Sonoma State University Art Gallery, Rohnert Park, California
	San Francisco Second Artists' Soapbox Derby: South Bay Entrants, Wordworks Gallery, San Jose, California
	Fine Design, Cal Expo, California State Fair, Sacramento, California
1977	*Kinetic Works*, Nevada Art Gallery, Reno, Nevada
	It's Electric, Euphrat Gallery, De Anza College, Cupertino, California
	Imaginings, The Allrich Gallery, San Francisco, California
	Contemporary Designs: Wood, Mount San Antonia College Gallery, Walnut, California
1976	*Slick*, Merz Gallery, San Jose, California
	Art That Rolls and Flies, Euphrat Gallery, De Anza College, Cupertino, California
	California Design '76, Pacific Design Center, Los Angeles, California
	American Crafts '76, Museum of Contemporary Art, Chicago, Illinois
	Selections from California Design '76, The Allrich Gallery, San Francisco, California
1975	*Artists' Soapbox Derby*, San Francisco Museum of Modern Art, San Francisco, California
1974	*Public Sculpture/Urban Environment*, Oakland Museum of California, Oakland, California
1973	*First International Motorcycle Art Show*, Phoenix Art Museum, Phoenix, Arizona
1971	*First Contemporary International*, Jan Morehead Gallery, Chico, California
	Group Invitational, Union Gallery, San Jose State University, San Jose, California
1970	*The Highway*, Institute of Contemporary Art, Philadelphia, Pennsylvania
	The Highway, Institute for the Arts, Houston, Texas
1969	*Electric Art*, Phoenix Art Museum, Phoenix, Arizona
	Electric Art, Dixon Art Center, University of California, Los Angeles
	Lodi Ninth Annual Art Show, Lodi, California
	Group Show, William Sawyer Gallery, San Francisco, California
	An American Report on the Sixties, Denver Art Museum, Denver, Colorado
	Wheels, San Francisco Museum of Modern Art, San Francisco, California
	Kinetics, Hayward Gallery, London, England
1967	*Lodi Seventh Annual Art Show*, Lodi, California
	Sacramento Autorama, Sacramento, California
	Nineteenth Annual Grand National Roadster Show, Oakland, California
1966	*Annual Student Exhibition*, San Jose State College, San Jose, California

PUBLIC COLLECTIONS

Art Gallery of Western Australia, Perth, Australia
Darwin College of Advanced Education, Darwin, Australia
Oakland Museum of California, Oakland, California
Queensland Art Gallery, Brisbane, Australia
Queen Victoria Museum and Art Gallery, Launceston, Tasmania, Australia
Salvador Dali Museum, St. Petersburg, Florida
Sam and Alfreda Maloof Foundation for Arts and Crafts, Alta Loma, California
San Jose State University, San Jose, California

PUBLICATIONS

Books and Catalogues

Aland, Jenny and Max Darby. *Art Connections*, first edition. Port Melbourne: Heinemann Educational Australia, 1991.

Aland, Jenny and Max Darby. *Art Connections*, second edition. Port Melbourne: Heinemann Educational Australia, 1998.

Barter, Tanya. *Bentwood*. Providence: Museum of Art, Rhode Island School of Design, 1984.

Cook, Robert. *Thing Beware the Material World*. Perth: Art Gallery of Western Australia, 2009.

Emery, Olivia H. *Craftsman Lifestyle - The Gentle Revolution*. Pasadena: California Design Publications, 1977.

Forty-eighth Annual Grand National Roadster Show catalogue. Oakland, California, 1998.

Forty-seventh Sacramento Autorama catalogue. Sacramento, California, 1997.

Lauria, Jo and Steve Fenton. *Craft in America*. New York: Potter Publications, 2007.

Meilach, Dona Z. *Woodworking: The New Wave*. New York: Crown Publishing, 1981.

Nagyszalancy, Sandor. *Setting Up Shop*. New Town: Taunton Press, 1998-1999.

Neubert, George W. *Public Sculpture/Urban Environment*. Oakland: Oakland Museum of California, 1974.

Roukes, Nicholas. *Masters of Wood Sculpture*. New York: Watson-Guptill Publishing, 1980.

SECA Art Award 1977 exhibition catalogue. San Francisco: San Francisco Museum of Modern Art, 1977.

SOFA exhibition catalogue. Chicago: Expressions of Culture, Inc., 1997.

The Gun Series exhibition catalogue. San Jose: San Jose State University, 1978.

Magazines and Newspapers

Artbook, journal, Vol. 5, No. 8 1979.

California Design '76. Home magazine, *Los Angeles Times*, 1976.

City Bike, March 1997: page 4.

Craft Australia, journal, summer issue 1979.

Drive, April 1997: page 19.

Harley Davidson & Buell Motorcycle News, June: page 6.

Headers on Steroids. Street Rodder, February 1996.

Kelsey, John. "Out West." *Fine Woodworking*, Vol. 2, No. 2 Fall 1977.

Street Machine, April – May 1997.

The Tubester. Street Rodder, November 1998 - summer 1999.

Wood Sculpture: Craft and Symbolism. The Columbus Dispatch, 1995.

Woodwork Magazine, February 1998.

Woodworker West Magazine, September – October 1998.

FILM AND VIDEO

Bartels, Dede. *Manta Matic*. Atherton, California, 1978.
Documents the construction of nitrogen-powered pneumatic coasting car plus some of the Second Artists' Soapbox Derby event; color film, twelve minutes.

Burrill, Robert. *Michael Jean Cooper: Sculpture*. Milpitas, California, 1978.
Documents large kinetic sculpture with hydraulic, pneumatic, and electric power systems as well as more recent work in laminated wood; 16mm color film, thirty minutes.

Jodrell, Stephen. *Craftsman in Industry*. Crafts Council of Australia, 1979.
Documents studio activities of Michael Jean Cooper, Craftsman Fellow, in an industrial situation; 16mm color film, ten minutes.

Pope, Amanda. *The First Artists' Soapbox Derby*. San Francisco, California, 1977.
Documents the event plus commentary and studio shots of various Bay Area artists; 16mm color film, twenty minutes.

Reynolds, Robert. *Turbo*. San Jose State University, San Jose, California, 1977.
Documents (with commentary by Michael Cooper) the construction of and studio activities surrounding *Turbo*, a full-sized laminated hardwood motorcycle; black and white film, twenty-two minutes.

Roe, Stuart. *Tubesteak City*. Los Angeles, California, 1975.
Documents construction, engineering, and installation of special projects in art class of instructor Michael Cooper; 16mm color film, twenty-five minutes.

Split Personality. Western Australia Institute of Technology, 1982.
Documents full construction of the commissioned sculpture for the Art Gallery of Western Australia; 16mm color film, ten minutes.

Working with Tubing. Covell Videos, 1998.
Documents various technical and aesthetic elements of exhaust systems for the Tubester project; six minutes.

Bibliography

MUSEUM OF CRAFT AND DESIGN
Office: 130 Bush Street, Floor Five
San Francisco, California 94104

Published in conjunction with the traveling exhibition
Michael Cooper: A Sculptural Odyssey, 1968 – 2011
organized by the Museum of Craft and Design.

Exhibition tour:

July 12–October 9, 2011, Bellevue Arts Museum, Bellevue,
Washington

November 12, 2011–May 13, 2012, Fuller Craft Museum,
Brockton, Massachusetts

June 14–September 16, 2012, Museum of Craft and Design,
San Francisco, California

Michael Cooper: A Sculptural Odyssey, 1968 – 2011 is made
possible, in part, through the generous support of the Windgate
Charitable Foundation.

Edited by Karin C. Nelson
Catalogue designed by Ron Shore, Shore Design
Principal photography: Michael Chase

ISBN: 978-0-9760119-3-4 (soft cover)
ISBN: 978-0-9760119-2-7 (hard cover)

Measurements for objects are given in inches in the order of
height, width, and depth, and represent the maximum dimensions
of a work unless otherwise noted.

Unless otherwise noted, all works are on loan from Gayle and
Michael Cooper.

Cover: *Ruby*, 2010; laminated hardwoods, chromed and painted
steel, anodized aluminum; 37 x 43 x 59.
Photo: Michael Chase

Printed and bound in Hong Kong